IMAGES
of America

WEST BROOKFIELD

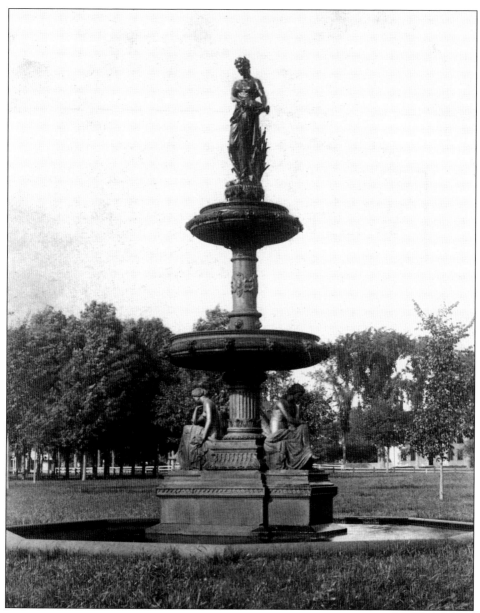

WELCOME TO WEST BROOKFIELD. This image predates 1910, due to the existing fence around the common that was later removed. The top statue was designed for the Paris Exposition in 1872; she is a water nymph, also referred to as *The Lady*. The fountain was available with two or four lower figures; the design with two was chosen and constructed by Fiske of New York and dedicated to the memory of the parents of George M. Rice. (Courtesy of the William H. Jankins Collection.)

ON THE COVER: KNOWLTON STEAMBOAT. Charles Knowlton was hired in the mid-1870s as superintendent of the W.K. Lewis Brothers Condensed Milk Factory. The Quaboag River has a long history of pleasure boating and the Knowlton family joined the fun. Pictured aboard his steamboat *Jennie*, Knowlton is at the helm with 20 passengers, and his daughter Jennie is on the bow of the boat holding the flag. (Courtesy of the William H. Jankins Collection.)

WEST BROOKFIELD

Brenda Metterville and William Jankins

ARCADIA
PUBLISHING

Published by Arcadia Publishing
Charleston, South Carolina

Printed in the United States of America

Library of Congress Control Number: 2014942358

For all general information, please contact Arcadia Publishing:
Telephone 843-853-2070
Fax 843-853-0044
E-mail sales@arcadiapublishing.com
For customer service and orders:
Toll-Free 1-888-313-2665

Visit us on the Internet at www.arcadiapublishing.com

To William Jankins—thank you for embracing and enthusiastically preserving the history of the town of West Brookfield.

And to Brenda Metterville—without her assistance, this book never would have been published.

CONTENTS

ACKNOWLEDGMENTS

William Jankins amassed an amazing collection of both images and resources used to research the history of West Brookfield. We did not have far to go to reference a fact within a resource—such resources extend from one end of the Jankins's historic residence to the other, in the private library, barn, and hidden storage areas. Many of these resources were used in writing this book, including town reports, taxes and valuations, bid documents from the early 1900s, and Worcester newspaper articles regarding West Brookfield in scrapbooks. William and Brenda give a heartfelt thank-you to Kate Simpson of Brookfield for her editing skills, as well as to the amazing outside resources William consulted: Jeffrey Fiske (author of *History of West Brookfield, 1675–1990*), Connie Small, Everett Allen, the Salem family, the West Brookfield Fire Department, Donald Richards, Barbara Smith, Robert Wilder, Roy Couture, the Quaboag Historical Society, Frank Morrill, Anna May Zabek, and John Kinnear of Digital-Vistas. William and Louise Jankins have both taken so much pride in this community of West Brookfield and put much effort into preserving the history of this wonderful small town. We apologize for any omissions, deletions, misspellings, or other errors; all such instances are purely unintentional. Unless otherwise noted, all images are courtesy of the William H. Jankins Collection.

INTRODUCTION

This picturesque glimpse into the past of West Brookfield during the 1800s and 1900s showcases the beautiful Lake Wickaboag and Quaboag River, downtown, and the farms. We highlight a storied past linked to the beginnings of our nation. Despite the demise of the factories, fruitful commerce still exists today, along with productive farms and townspeople proud of the long-standing history of the first parish of the Quaboag Plantation.

The following is from the West Brookfield Historical Commission website and used with the chair's permission:

> West Brookfield has the sites of the first white settlement, the Indian villages, and is in reality the mother town of the Quaboag Plantation. The Quaboag Plantation was deeded in 1660, and 13 years later this area was incorporated as a town and was called Brookfield. Quaboag is a Nipmuk Indian name meaning "before the pond." The site of the largest of the Quaboag Indian villages was at Wekabaug, later known as Wickaboag. This site joined the southerly end of what is now Lake Wickaboag in West Brookfield. With the advent of the railroad, West Brookfield was incorporated as a separate town in 1848.

Evidenced by many narrations, sermons, and artifacts, the Old Indian Cemetery near Lake Wickaboag was close to where the largest Quaboag Native American tribes lived on the plantation. The Haymaker monument resides there in honor of the planters killed in 1710. This was the last of the malice between the settlers and the natives. There are also references to the West Parish Brookfield as the first precinct. North Brookfield, established in 1812, was the second precinct. Brookfield was the third precinct and most times was referred to as the South Parish Brookfield.

John Pynchon, prosperous merchant, magistrate, and fur trader, was likely instrumental in getting the original families from Ipswich to settle here, as there was a need for a midway station between the villages of Marlboro, Lancaster, and those to the west along the Connecticut River. As noted in the book *Quaboag Plantation Alias Brookefeild* by Dr. Louis Roy, the most important single business in any community in the early days of the colony was a gristmill. In August 1669, Quaboag constructed a water-powered mill on what is now called Sucker Brook (named for the abundance of this type of fish) financed by John Pynchon. Prior to this date, all grains had to be transported to Springfield for processing. It appears that after November 23, 1669, all grain and corn was milled at the Pynchon site. This mill site and the surrounding 42 acres were recently purchased by the East Quabbin Land Trust and will be called Pynchon's Grist Mill Preserve. Dr. Roy states, "The remains of this mill site and the artifacts found here are probably the oldest relics in existence of the Quaboag Plantation and its most important mercantile structure."

West Brookfield was home to numerous influential people, including Jedediah Foster, who was born on October 10, 1726, in Andover. He graduated from Harvard in 1744 and practiced law at his home and office in West Brookfield (then known as Brookfield), built in 1729 by his father-in-law.

His wife, Dorothy Dwight, was the daughter of Gen. Joseph Dwight. The Fosters reared a family of seven children, including two future senators—Theodore and Dwight Foster. Jedediah's list of offices is impressive: he was a colonel in the militia during the Revolutionary War, fought at Lexington on April 19, 1775, was elected delegate to the First Provincial Congress, and served as a judge of probate and common pleas for Worcester and justice of the superior court of Massachusetts. He was one of the four judges at the county's best-known murder trial, that of Bathsheba Spooner in 1778. Foster was also one of three judges chosen to draw up the original draft of the constitution for the new commonwealth of Massachusetts. He died on October 17, 1779, before finishing the work; his son Dwight was appointed to complete the work on the draft.

In 1791, David Hitchcock and Dwight Foster granted a town common to the "inhabitants of the First Parish in the Town of Brookfield aforesaid in their corporate capacity by whatever name they are known." In 1873, J. Henry Stickney established a $3,000 fund for the beautification of the common, which paid for grading, planting of trees, and establishing walkways around and through the common. The town voted to appropriate $500 to improve the roads surrounding the common.

Lucy Stone and her family attended the speech of abolitionist Abby Kelley in 1836 at the West Brookfield Congregational Church. It is said her father was the one to bark insults during the presentation. During the congregation's vote to dismiss the minister who allowed the Kelley presentation, Lucy Stone's vote was not counted because she was a woman. In 1851, Lucy Stone was expelled from the Congregational church, mostly because her public speaking was not considered proper for women during those times.

In 1880, Charles Merriam donated a sum of money for the town to build a library. The Merriam Public Library, located on the corner of Main and Cottage Streets, cost $15,046, including the purchase of the land.

In 1884, George M. Rice donated the two Fiske fountains on the common in memory of his parents, the Rice Memorial Fountains. The fountains were supplied with water from a reservoir one mile away, built with town funds. The community's earliest days were also committed to education, and rural school districts were established with some original school buildings used through the 1950s.

Helen Paige Shackley was the town librarian for 30 years, town treasurer for 32 years, and town clerk for many years. In 1925, she largely disputed the fact that the *Merriam-Webster Dictionary* was published here; it was, in fact, published in Springfield. The Merriams had published a dictionary in their West Brookfield publishing house, but it was not the Webster edition. In 1963, the town voted to accept a $50,000 legacy from Shackley, designated for the construction of a bandstand on the common. The bandstand was erected on the site of the West Brookfield School Street School, later the elementary school, and was dedicated in 1972.

The most recent donation in the town of West Brookfield was the 75-acre tract known as the Rock House Reservation, given to the Trustees of Reservations by Walter and Dorothy Fullam of West Brookfield and Princeton, New Jersey.

Today, West Brookfield residents, summer residents, and merchants take care to preserve this vibrant, historic town. Visitors are attracted to this small community for events such as the annual Asparagus Festival, held in May to remember Diederick Leertouwer, the Dutch envoy to Massachusetts and New Hampshire who had his favorite spring vegetable shipped to America in 1794. He shared it with his neighbor Dwight Foster, and the distribution was very fruitful, now celebrated yearly with a full day of activities, music, children's games, over 100 vendors, and many different and deliciously prepared asparagus treats. Thousands of visitors come to West Brookfield also for the summer outdoor concerts, held on the common for over 40 years, and the White Christmas festival, with homes decorated with white Christmas lights, a huge tree-lighting ceremony on the common, and a choral concert in the town hall. The Quaboag Historical Society Museum is located in the former Boston and Albany Train Depot and has rotating displays on the history of the Brookfields, Warren, and New Braintree.

One

LOOKING BACK

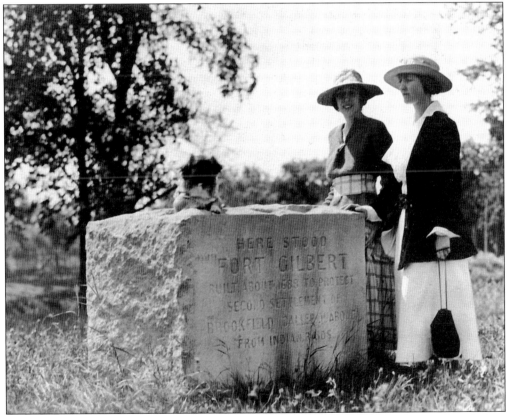

FORT GILBERT, 1919. Constructed around 1688 to protect the Quaboag settlement from Indian raids, this fortification was built by carpenter Thomas Gilbert, brother to Capt. Henry Gilbert. Located on North Main Street, the large fort was surrounded by a stockade, and 10 men were garrisoned there to protect settlers. Pictured, from left to right, are Sun Yen, Jeanne Habben, and Molly Habben. (Photograph by John Ingliss Habben, courtesy of Lindsey E. Smith Jr.)

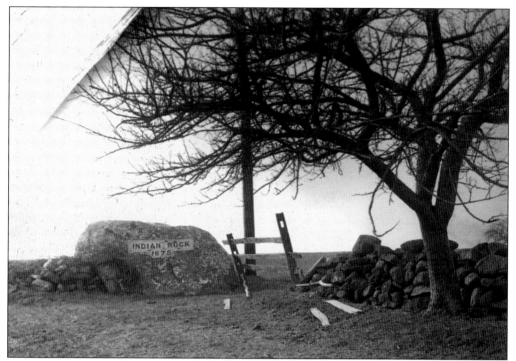

INDIAN ROCK. Nipmuks took refuge here while attacking the settlers in August 1675. They burned the town, destroying the first meetinghouse, tavern barn, and cattle. During this three-day siege, survivors remained in the fortified Ayres Tavern, a garrison, until reinforcements arrived to turn the tide of the battle.

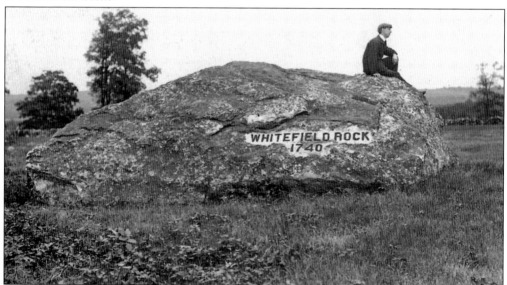

WHITEFIELD ROCK. George Whitefield was a "divine dramatist," promoting Evangelicalism. Reverend Cheney of the Congregational church refused to invite Whitefield to preach in his meetinghouse in 1740. Whitefield gathered his followers of more than 500 to this field and used the rock as his pulpit. He was known for his mimicry and theatrics; Reverend Cheney was duly impressed and endorsed Whitefield after his sermon. (Photograph by Charles H. Clark.)

OLD ELLIS MILL, 1923. Ellis Brook is the dividing line between West Brookfield and Warren, located near Henshaw Farm. This mill produced a legendary scarlet fabric presented to George Washington in 1795. Washington's secretary penned a thank-you to mill owners Dwight Foster and a Mr. Ellis, writing that "the discovery of the scarlet dye may answer his most sanguine expectations." (Photograph by A. Stoddard.)

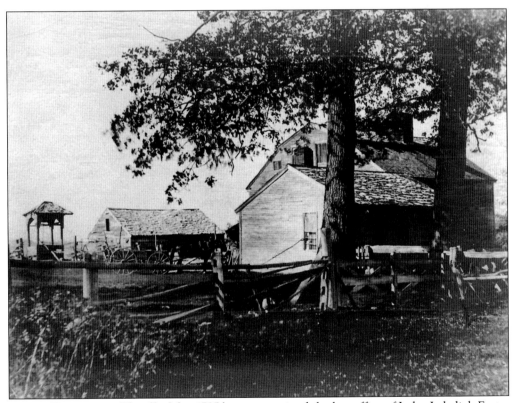

FOSTER HOMESTEAD. The ell of this 1735 house contained the law office of Judge Jedediah Foster (1726–1779), who helped draft the Massachusetts Constitution and was one of four judges for Bathsheba Spooner's 1778 murder trial. Descendants of Dwight Foster, also a judge, deeded the property to the Quaboag Historical Society, but it was destroyed by fire in November 1901. (Photograph by Charles H. Clark.)

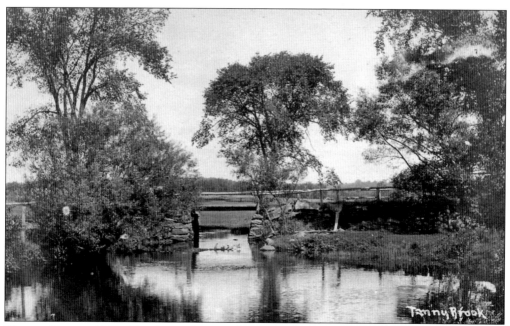

TANNEY BROOK, 1903. The above photograph captures the view south from the bridge over Coy Brook, which was named after an original settler, Richard Coy Sr. He signed the petition to the General Court to establish Quaboag Plantation on October 10, 1673. The General Court, by act, established Brookfield on October 22, 1673. It was known as Tanney Brook for the tannery pictured below, established on the north side of Foster Hill Road and owned by local entrepreneur Chandler Giddings; he was a member of the school committee, served on the board of selectmen, and owned five private homes and several businesses in the early 1860s. H.S. Haskins operated the tannery. (Photographs by Charles H. Clark.)

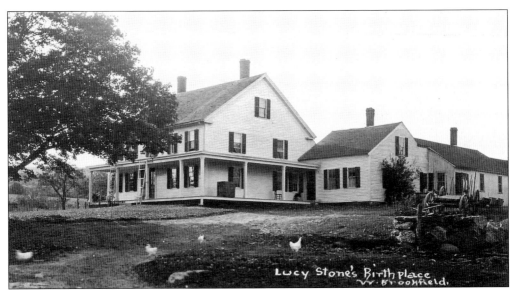

LUCY STONE'S BIRTHPLACE, 1900. Born in 1818 on her family's farm on Coy Hill, Lucy Stone possessed idealism that was ingrained early. She defied her parents by attending college as her brothers did and was one of the first women in Massachusetts to obtain a college degree. She became an acclaimed speaker for women's rights and abolition. The 16-room house and barn were destroyed by fire in 1950. (Photograph by Charles H. Clark.)

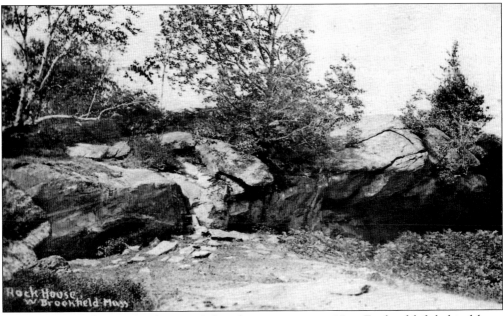

ROCK HOUSE. Thousands of years of glacial movement over New England left behind large numbers of boulders and stone outcrops. The Rock House is located near two Native American footpaths and may have been used as a camp. Walter Fullam donated the property—part of a 281-acre farm owned by William Adams for over 125 years—to the Trustees of Reservations in 1993. (Photograph by Charles H. Clark.)

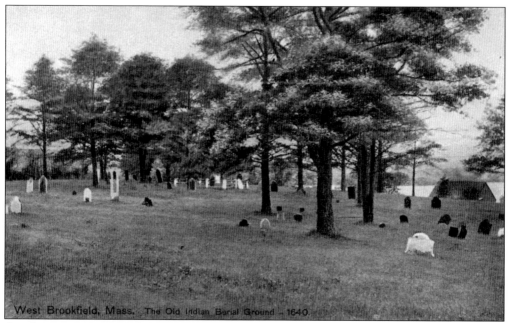

OLD INDIAN CEMETERY. The first established community cemetery was located on Cottage Street overlooking Lake Wickaboag. In 1912, a memorial was erected in honor of Haymaker settlers killed in July 1710 by Native Americans. Jedediah Foster, the "wisest, truest patriot," is buried here. Dutch consul Diederick Leertouwer, of asparagus fame, is also buried here. (Photograph by Charles H. Clark.)

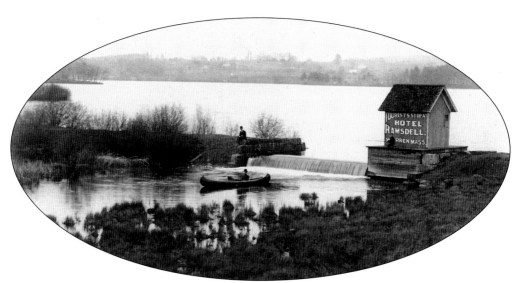

LAKE WICKABOAG DAM. Warren Cotton Mill paid the Town of West Brookfield for use of water from Lake Wickaboag. In 1885, the mill paid $119.83 to the town and was in the top five non-resident taxpayers. The company paid taxes into the mid-1930s. The advertised Hotel Ramsdell on Main Street in Warren was built by William Ramsdell in 1886. It no longer exists today. (Photograph by Eddy Make.)

Two

RIVERS AND LAKES

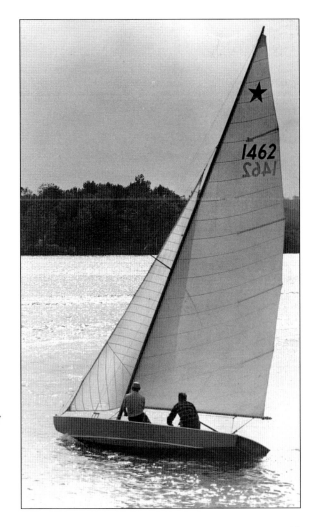

STAR SAILBOAT NO. 1462. Sailing on Lake Wickaboag was quite popular in the 1950s. Regattas were held every summer through Wickaboag Boat Club. Walter Reynis (left) is crew, on main sheet, and at the tiller is Lindsey Smith. This boat was designed in the 1910s for lake sailing. The Marconi rig had a fixed keel weighing 900 pounds, and its overall length was 22 feet and nine inches, sail and jib. (Photograph by Leslie Campbell.)

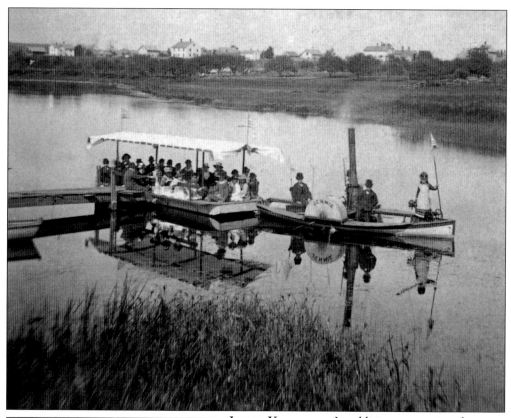

JENNIE KNOWLTON. In addition to running the steamboats, Charles Knowlton set up Knowlton Camp a quarter of a mile east of where he launched the boats, located under William Lincoln's woods on Long Hill Road. He set up tents, refreshments, and furniture and toys for children. His son, George, took over running the boats in 1895. Knowlton also had rowboats available for locals to rent. In the background are homes on Ware Street, which runs parallel to the railroad tracks. Jennie (pictured at left), daughter of Charles and Jane Knowlton, was born in 1870; the family moved to West Brookfield in the mid-1870s.

Penfield, - - Warren, Mass

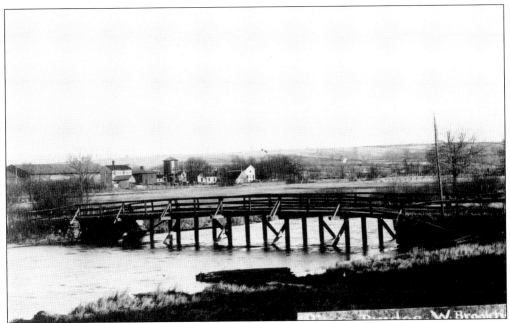

FIRST QUABOAG RIVER BRIDGE. Constructed in the early 1800s, this bridge has a notable elevation due to the traffic on the river. Not only did this bridge accommodate steamboats, it provided room for barges holding bricks that were made upriver and sent to the Brookfield depot for transporting. The W.K. Lewis Factory is located 100 yards to the west. (Photograph by Charles H. Clark.)

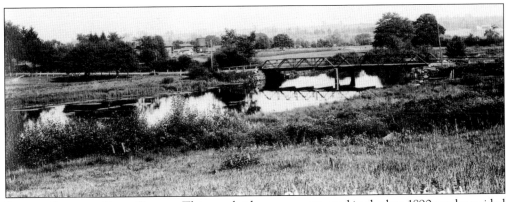

SECOND QUABOAG RIVER BRIDGE. This new bridge was constructed in the late 1890s and provided a stronger surface for shipping products to and from the W.K. Lewis Condensed Milk Factory. The demise of the brickworks in the early 1900s allowed for a lower profile for the bridge. A second icehouse was located over this bridge to the left on the river. (Photograph by Charles H. Clark.)

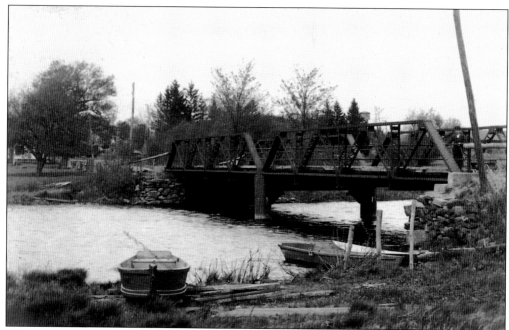

KNOWLTON BOATS. The construction of the second Quaboag River bridge may be noted by the strong stone foundation on the riverbank and the steel construction of the frame. In the foreground are the supports for the docks used by Charles Knowlton to store and launch his boats for public use. (Photograph by Charles H. Clark.)

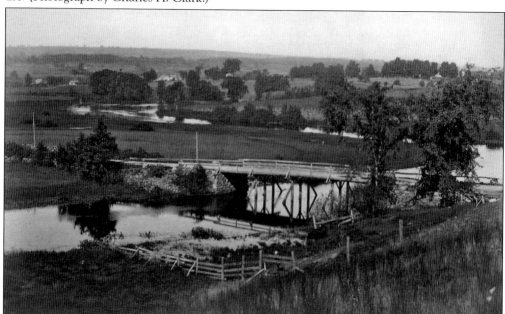

HATHAWAY'S CROSSING. This bridge led to Warren and was replaced in 1883. Hathaway refers to the brickworks made accessible by this bridge. Visible in this photograph are Henshaw Farm and a brick house constructed of West Brookfield bricks (top right); Lashaway, where the water enters the Quaboag River from Lake Wickaboag (right); and in the shallows of river, a weir built by Native Americans to catch fish is still there today (left).

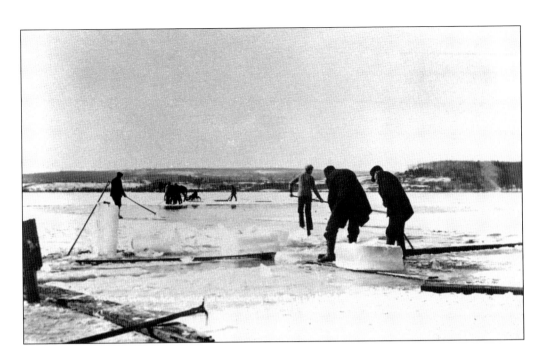

ICE HARVESTING. A February 1906 *Cold Storage and Ice Trade Journal* notes that "Alva Sykes, of West Brookfield, filled his ice house with good quality ice 10 inches thick." The icehouse was built on the shore of Lake Wickaboag, near Chapman's Beach. Ice-harvesting from the lake began in the 1800s. The ice harvest usually came towards the end of January or early in February, when ice was about 10 inches thick. The best temperature for cutting was a few degrees below freezing, so the water would freeze quickly on the cakes after they were taken out of the lake. The trick was to give the cake of ice enough momentum so its weight would carry it up where someone with a pair of tongs could snag it to be near the conveyor for storage. (Photographs by Charles H. Clark.)

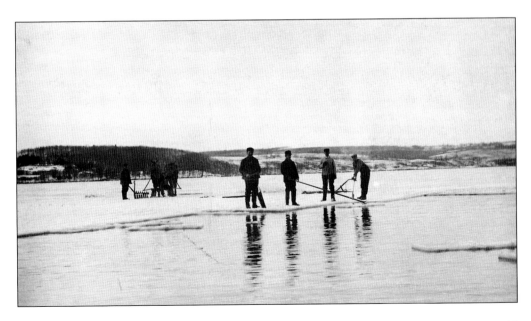

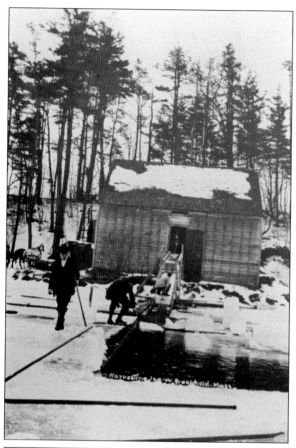

ICEHOUSE, 1895. Ice harvested from the rivers and ponds of New England was a highly valuable resource in the 19th century. Ice was shipped to other parts of the United States in the days before refrigeration. In 1890, three million tons of ice were cut in Maine alone, requiring 25,000 men and 1,000 horses. Large blocks of ice were cut in the winter, lifted by a conveyor, and stacked in the icehouses on Lake Wickaboag. The long plank sloped into water, and the ice was hauled up to the icehouse on a two-horse pulling system. The team is seen to the left of the building. Layer by layer, the icehouse was filled; to help prevent the huge blocks of ice from melting, they were covered with sawdust so they could be sold in the warmer months. (Photographs by Charles H. Clark.)

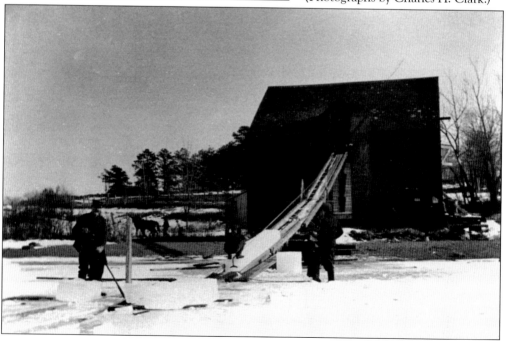

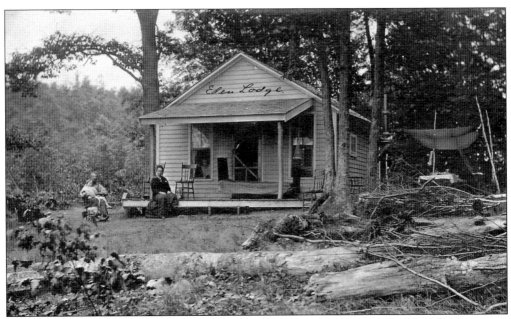

EDEN LODGE, 1911. From the town of Ware, this family is relaxing at a Lake Wickaboag cottage. Note the outdoor picnic set up to right of cottage. Gustave C. Tanski owned Lakeview Farm on Wickaboag Valley Road, and he built six cottages to rent. His cottages were named Glenoak, Sunset, Bohemia, Oak Bluff, Eden Lodge, and Green Nook. This area is known as Council Grove, formerly Oak Grove. (Photograph by Charles H. Clark.)

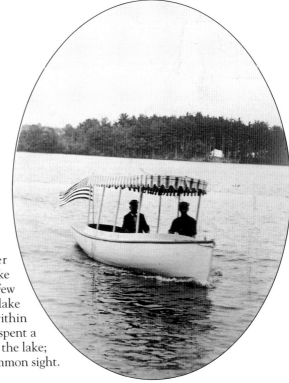

MOTORBOAT, 1908. These dapper gentlemen take a motorboat cruise on Lake Wickaboag during the summer of 1908. Few homes, camps, and boats were on the lake early in the 1900s. A tent camp is seen within the trees on the opposite shore. People spent a week or more camping in groves around the lake; the glow of campfires at night was a common sight. (Photograph by Eddy Make.)

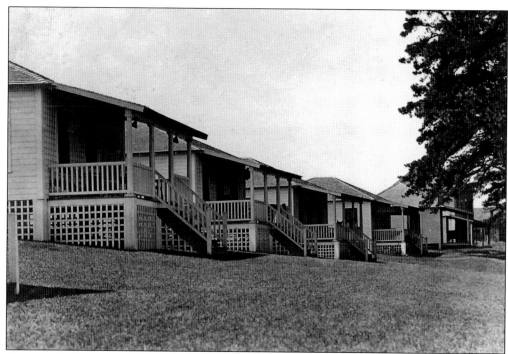

CHAPMAN'S COTTAGES. At the end of Chapman Avenue, Charles E. Chapman had 11 cottages constructed by 1919; they sat on a bluff with waterfront views. Chapman had also constructed a 20-by-20-foot clubhouse to complete his Bungalow Park. Due to popularity of his park, the town approved $50 for a swimming raft near his beach in 1926. (Photograph by John Ingliss Habben, courtesy of Lindsey E. Smith Jr.)

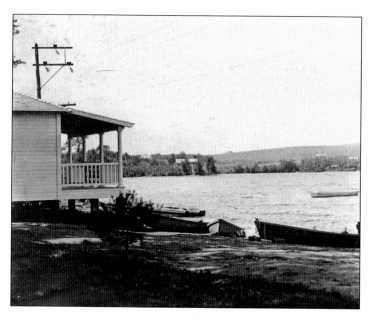

CHAPMAN COTTAGE, 1919. Charles E. Chapman constructed his cottage below the bluff of rented cottages for his waterfront enjoyment. He provided boats for renters as they summered on Lake Wickaboag. Due to the camp's proximity to town, he had four canoes to rent to the public. In 1926, the fire department stored its lungmotor in his clubhouse in case of drowning victims. (Photograph by John Ingliss Habben, courtesy of Lindsey E. Smith Jr.)

OLD ICEHOUSE. Benjamin P. Aiken's icehouse on Lake Wickaboag did not appear on local atlases until Walker's *Atlas of the Brookfields* in 1885. Alva Sikes (Sykes) appeared to succeed a successful Aiken in 1901, but he sold his ice business to Waldo Mason in 1915. Sikes retained the land and icehouse. (Photograph by Charles H. Clark.)

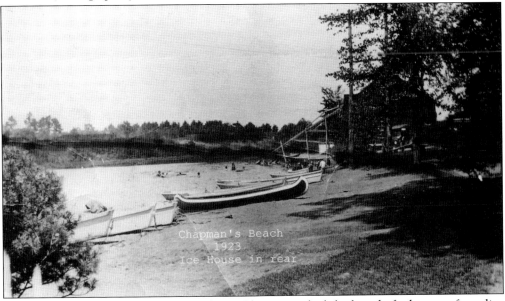

BUNGALOW PARK, 1923. In 1929, Charles E. Chapman asked the board of selectmen for police protection for Saturdays and Sundays at the park, due to the number of unsupervised children and young adults. His request was approved. The icehouse and the conveyor built were part of the Chapman Beach area. Chapman was from New York City, and his two daughters married locally. Vivian married George Gilman, and Beatrice married Sherman McCarthy.

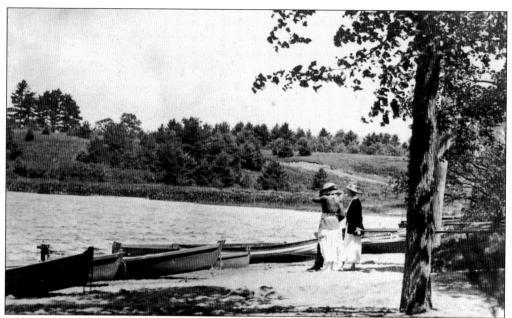

POPULAR LOCAL BEACH, 1919. Molly Habben (left), and Jeanne Habben enjoy a summer visit to the public beach area Charles E. Chapman continued to improve. While other lake improvements were catering to out-of-town renters, Chapman provided a beach and boats on the southern side of the lake for the locals to enjoy. (Photograph by John Ingliss Habben, courtesy of Lindsey E. Smith Jr.)

WICKABOAG VALLEY ROAD. Pictured here is the northwest end of the lake heading towards Ragged Hill Road. Note the level of the water in relation to the roadway, which has only cart tracks and is unpaved. This 1904 photograph indicates a very low water level, but this is not unusual in midsummer on Lake Wickaboag. (Photograph by Eddy Make.)

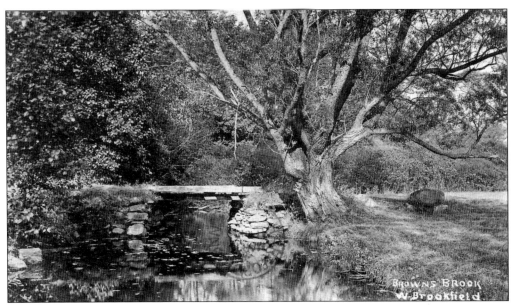

BROWN'S BROOK, 1906. This section of Coy Brook located behind the Brown residence and shoe factory was an early traditional 1940s swimming place for the Boy Scout Troop 118 after marching in the Memorial Day parades. At this time, the area was part of the Townsend Dairy Farm.

CONVERTED STEAMBOAT. At dock in front of Nils Anderson's year-round home on Lake Wickaboag, this boat was named *Mabel F* when owned by Frederick Farmer. When Anderson, a member of the Wickaboag Boat Club in the 1950s, purchased it, he renamed it *Christine*. This vessel was a steamboat converted to a four-cylinder internal combustible gas engine, and it led many Sunday boat parades on the lake.

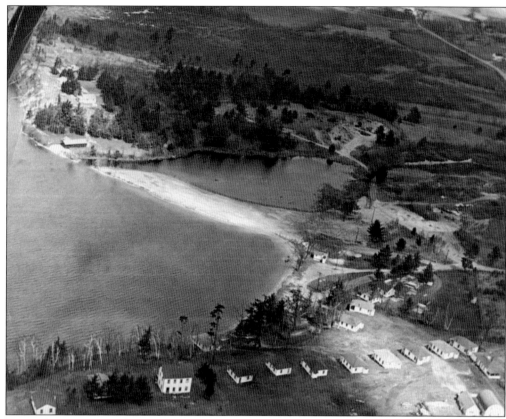

TOWN BEACH, 1940s (ABOVE); LAKE SHORE DRIVE, 1950s (BELOW). At the 1944 annual town meeting, West Brookfield accepted land from H. Burton Mason at the end of Cottage Street. The gift was intended to be a town beach at the east and south side shore of the lake. By 1946, swimming lessons started for the locals and visitors. In 1952, highway superintendent Theodore E. Prizio began transferring fill from road construction on Long Hill Road to the town beach to create more parking and a larger beach area. Chapman's cottages can be seen at the bottom of the image. Lake Shore Drive is pictured below during the 1950s.

Three

RECREATION

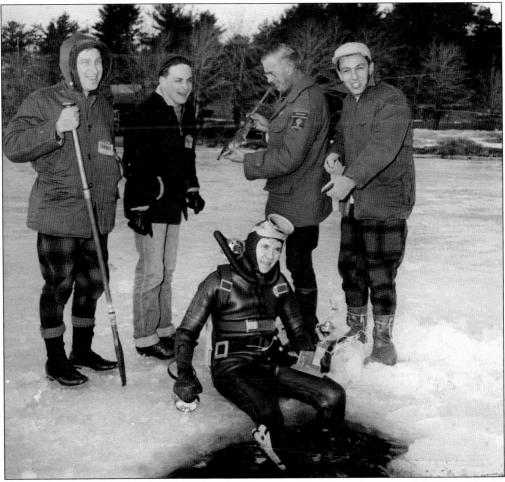

FISHING DERBY, 1960. Brookfield Machine's J. Irving England hosted an annual fishing derby for employees on Lake Wickaboag. Prizes were awarded for largest fish in several categories. Pictured, from left to right, are Jean Ziemba, Rollo Plumbly, game warden Oscar Cregan, Dale Tripp, and Roy Couture (in wet suit). (Courtesy of Roy Couture.)

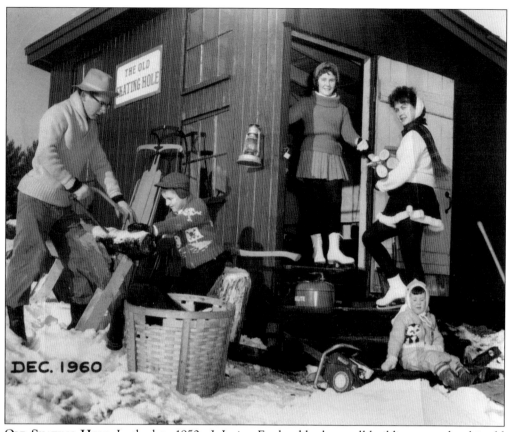

OLD SKATING HOLE. In the late 1950s, J. Irving England had a small building moved to his old skating hole adjacent to Frog Pond, on the shore of Lake Wickaboag. Pictured above are, from left to right, Lance Whitcomb, unidentified, Susan O'Hara, Gail Benoit, and unidentified. This building had wooden benches around the interior perimeter and a small cast-iron stove for comfort. All were invited to use this building, and children were issued membership cards. The only rules were to "sweep the building clean and fill the wood box." Boys and girls, parents, and grandparents enjoyed and played ice hockey and held skating parties while enjoying hot dogs, hamburgers, and hot chocolate throughout the winter. Below is a membership card indicating Donald Richards is a member in good standing. (Above, photograph by J. Irving England.)

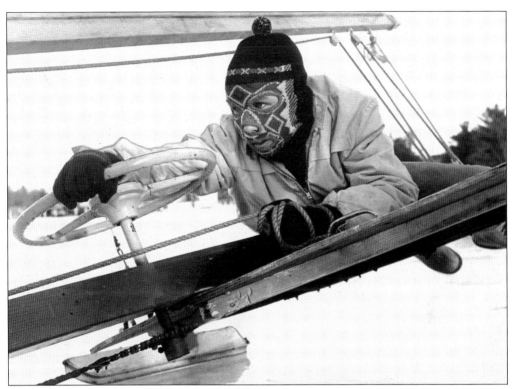

DANIEL BUZZELL, 1961. While summer sailing in the sun is thrilling and exciting, it cannot compare to iceboating on a cold, frigid, windy day. The speed of an iceboat on three narrow steel runners propelled by a stiff breeze on smooth ice is an incredible thrill. The crew on this boat is riding a mere eight inches off the ice.

FIVE-PERSON PYRAMID WATERSKIING. Members of the several ski clubs on Lake Wickaboag in the 1950s spent many hours on shore to perfect a pyramid such as this, learning the balance and maneuvering required to be successful. Mimi Frey (left) and Susan Wakeman balance atop holding the flag, and on water skis are, from left to right, James Boyko of Belchertown, Kenneth Cross of Wilbraham, and Edward Campbell of Ware. (Photograph by Leslie Campbell.)

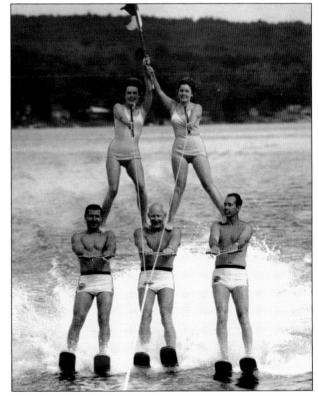

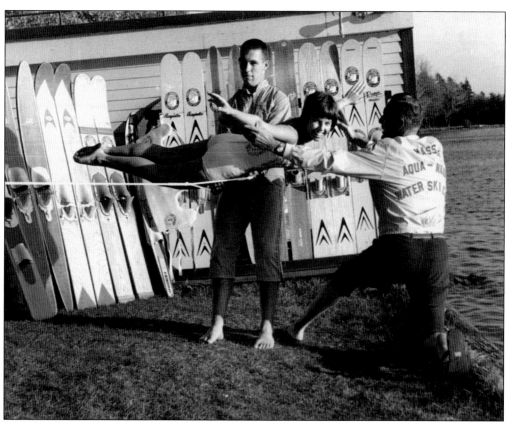

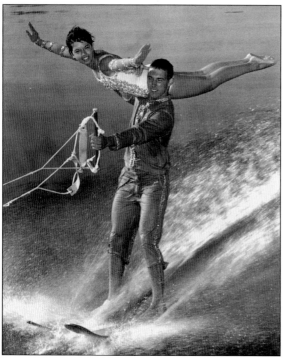

NATIONAL CHAMPIONS, 1963.
Members of the three ski clubs located on the lake often placed in the top five in regional and national events. Mass Aqua-Nauts Albert Collings and Sharon Willett, shown practicing above, were the national champions in the 1963 mixed doubles event held in Long Beach, California. Glenn Gray, director of the Mass Aqua-Nauts, instructs Willett on the grounds of the club. Each routine required hours of practice on land before being attempted on water. In the photograph at left, Willett and Collings perform one of many routines required. At this point in the competition, Willett is completely barefoot and will have to complete the routine with Collings on one pair of skis.

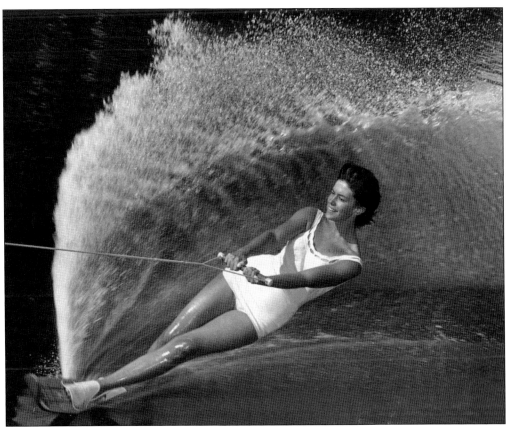

SLALOM SKIING. From the late 1950s into the mid-1960s, Lake Wickaboag was a mecca for local waterskiing. In summer, morning through evening, the sound of V-8 inboard boats could be heard as they pulled skiers practicing for local and national competitions. Here, Lee Reynis, age 16, throws up a wall of water while making a sharp cut on the slalom ski during a performance. (Photograph by Leslie Campbell.)

PRACTICE TIME. Competition waterskiing has four events: slalom, tricks, jumping, and mixed doubles. Lake Wickaboag usually had participants in all four; numerous hours of practice were required. Practices had numerous failures before achieving perfection. Here, Tim Beaulieu of Longmeadow loses one ski after going over a jump, resulting in an undignified landing. More practice was going to be required before competition. (Photograph by Leslie Campbell.)

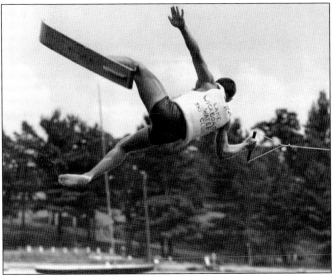

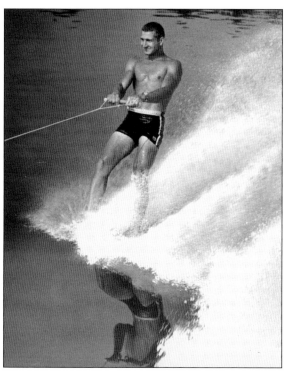

BAREFOOT WATERSKIING. Barefoot skiing on Lake Wickaboag was a common occurrence due to availability of the power and speed of inboard boats. James Boyko of Belchertown displays excellent form; note his reflection in the water and the absence of a life preserver. Unfortunately, there is no gliding to end this event, only a tuck and roll. (Photograph by Leslie Campbell.)

ANNUAL REGATTA, 1962. Kenneth Cross of Wilbraham performs a slalom event with Mimi Frey on his shoulders, turning before the reviewing stands at the annual regatta of the Wickaboag Boat Club. Cross was an extremely powerful skier; he once did a deepwater takeoff on a slalom ski with Frey on his shoulders. This activity required a powerful boat and a pair of excellent skiers. (Photograph by Leslie Campbell.)

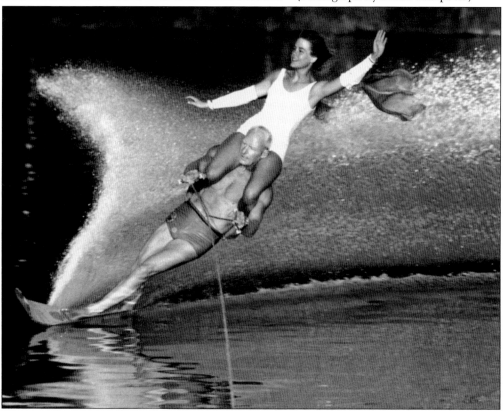

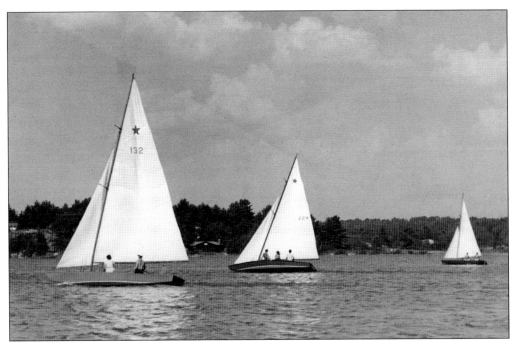

SAILBOAT RACES. From the 1950s to 1970s, the Wickaboag Boat Club had several Star-class sailboats, and weather permitting on summer Sundays, the races were on. A Star boat has a 900-pound fixed keel and is almost 23 feet in length with Marconi rigging. These three boats were manufactured in the 1920s and are still competitive 50 years later.

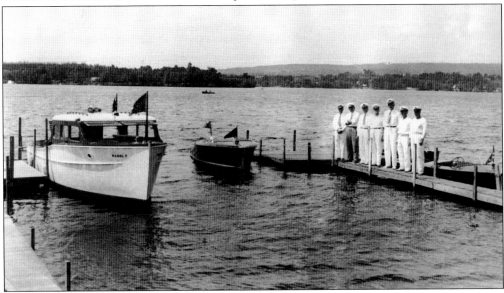

WICKABOAG BOAT CLUB OFFICERS. In 1948, officers for the club (founded in the 1930s) are, from left to right, John Hannigan (captain, Brookfield), H. Burton Mason (treasurer, West Brookfield), Leroy Latown (vice commodore, Spencer), Frederick Farmer (commodore, Worcester), Harry Bousquet (rear commodore, West Brookfield), Arthur Tolman (lieutenant, Gilbertville), and Carl Martin (director, Springfield). The boats are *Mable F.* owned by Farmer, and two Chris-Crafts owned by Bousquet and Hannigan, respectively.

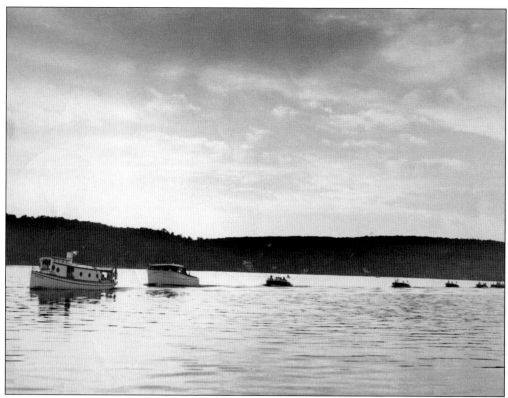

BOAT PARADE, 1948. Boat parades were a tradition on Sunday evenings and originally began following the Wickaboag Boat Club's annual regatta in August. This parade in August 1948 shows 7 boats; probably another 15 are not shown. Currently, boat parades often exceed 50 boats. Boat owners, from left to right, are Nils Anderson, Frederick Farmer, Leroy Latown, H.N. Foster, John Hannigan, Arthur Tolman, and Albert Collings.

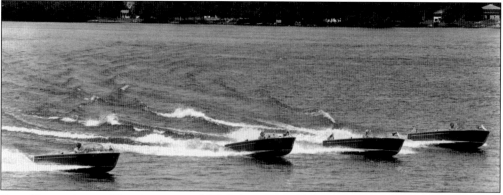

BOAT RACES. A crowd favorite at annual Wickaboag Boat Club regattas was watching inboard boat races. Boats made by Chris-Craft, Century, and Correct Craft primarily competed. A handicap was applied to the boats by judges before the races. A serious accident involving two Centuries brought this event to a final conclusion. No serious personal injuries occurred, but two fine boats were destroyed. (Photograph by Leslie Campbell.)

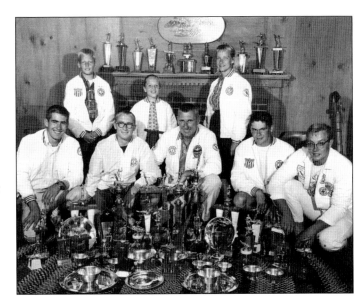

WICKABOAG SKI CLUB AWARDS. Displaying regional and national trophies, from left to right, are (first row) Raymond Arsenault, Timothy Beaulieu, Lex Carroll, Brian Roy, and Bradley Leland; (second row) Blake Carroll, Kristen Carroll, and Jane Carroll. Lex and Jane competed in the senior division, Blake and Kristen in the junior division, and Raymond, Timothy, and Brian in the men's division with Bradley as boat driver. (Photograph by Leslie Campbell.)

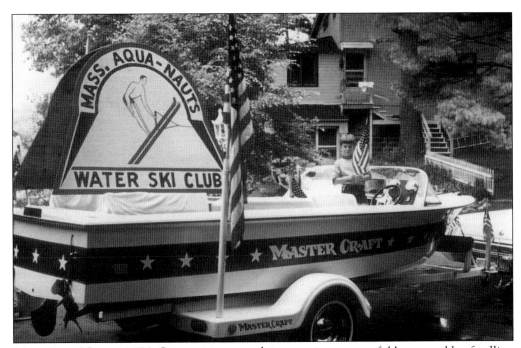

MASS AQUA-NAUTS, 1976. Competitive waterskiing requires a powerful boat capable of pulling multiple skiers at speeds up to 40 miles per hour. These boats are expensive to purchase and maintain and require large amounts of fuel. Parents, advisors, and generous benefactors often provided necessary funds. Steve Anderson (holding flag) is pictured in a parade-ready Master Craft. For many years, mahogany-hulled Century boats were used. (Photograph by Leslie Campbell.)

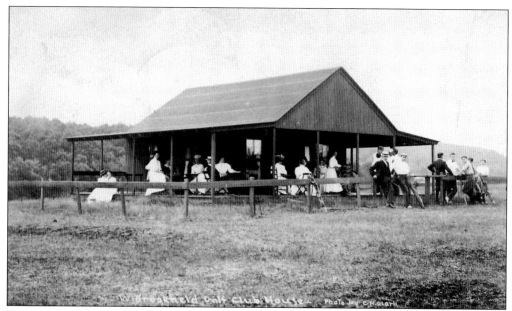

WEST BROOKFIELD GOLF CLUB, 1909. This club was organized in 1904 by local dentist Clement Bill (president), Mary Elizabeth Olmstead (vice president), and Arthur Webb (secretary and treasurer). Alfred C. White agreed to lease a tract of land on an annual basis for the purpose of golfing. This almost 40-acre tract of land, on farmland east of Salem Cross Inn, was named Highland Links after the Scottish game.

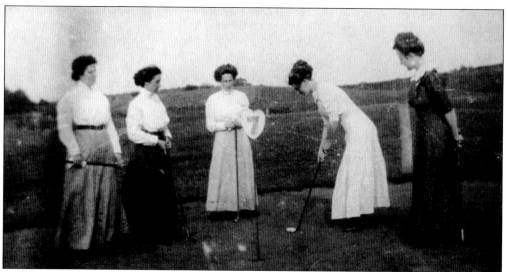

LADIES GOLFING. This early 1900s image shows four female golfers taking turns on the putting green, not deterred by long dresses and shoes with heels. Evidently, it was not necessary to remove the pin before putting, and the numbered marker shows they are on the seventh green of Highland Links.

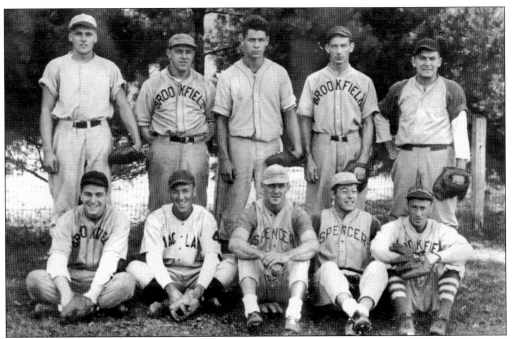

BROOKFIELD TOWN TEAM, 1941 CHAMPIONS. This all-star baseball team assembled from local towns traveled the area playing other all-star teams and won the 1941 championship. The home games were played on the West Brookfield common. Pictured, from left to right, are (first row) Raymond Gadaire, Townsend Powell, Andrew Ethier, Norman Ethier, and Ralph Boulette; (second row) Hammond Wheeler, Charlie Burnham, Donald Wallace, Henry Harder (manager), and Albert Fecteau.

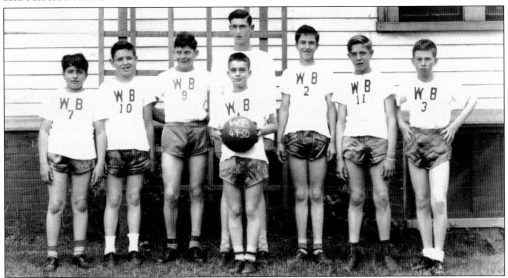

ELEMENTARY SCHOOL BASKETBALL, 1949–1950. Standing in front of the School Street School (present site of the bandstand) are, from left to right, Richard Faugno, William Jankins, Roger Labier, Lawrence Potter, James Wright (with ball), Buddy Ingalls, Wayne Smith, and Philip Smith. The school did not have a gymnasium; all practices and games were played in the main hall of the town hall. Many other school teams also played in their town halls.

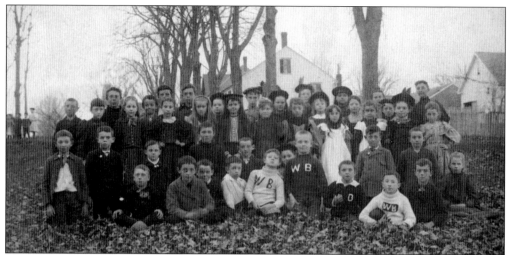

FOOTBALL PLAYERS, MILK STREET SCHOOL. Students from first grade through third grade gather in 1896 in front of their school. Select students of the football team are dressed for the game. Known students include Annie Barrett, Kenneth Garrett, Carroll Clark, Alfred Adams, Arthur Warfield, Ruby Blair, John Connolly, Bessie Ducy, Nellie Hyland, and Elizabeth Bill. The teacher, Miss Morey, stands in the back right.

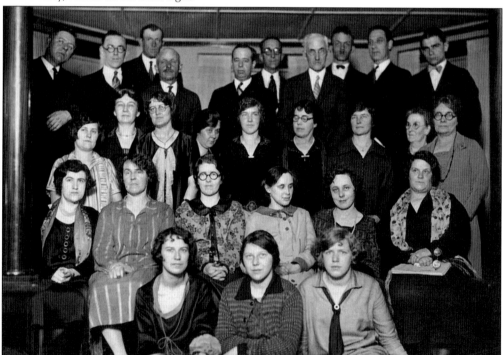

WEST BROOKFIELD COMMUNITY CHORUS, 1932. Pictured, from left to right, are (first row) Freeda Huyck, Olive St. Denis, and Olive Stirling; (second row) Eleanor Morgan, Frances King, Carrie Allen, Marion Chesson, Marguerita Fales, and Molly Ottenheimer; (third row) Florence King, Helen Brigham, Edna Nelson, Margery Jaffrey, Odissa Paraday, Eva Wheeler, Cora Edson, and Marion Reid; (fourth row) Napoleon St. Denis, Walter Skiffington, Arthur Warfield, Frederick Smith, Allen Campbell, Arthur Brigham, A.A. Blount, Milton Griffin, J.A. Paraday, and Charles Burgess.

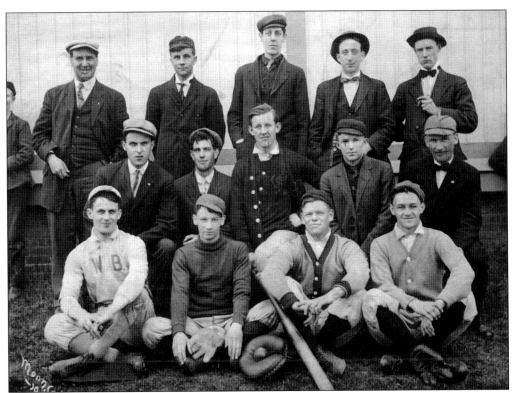

WEST BROOKFIELD BASEBALL TEAM, 1910. An 1892 vote allowed baseball to be played on the common every Saturday with out-of-town teams. Connie Mack lived in West Brookfield at the time. Pictured, from left to right, are (first row) Webster Kendrick, Peter Brady, Earl "Whip" Livermore, and John Brady; (second row) John Fitzgerald, William Macuin, Robert Converse, Arthur Stone, and Frank Stone; (third row) Herbert Woodward, Frank Brown, Paul Allen, Henry Barrett, David Robinson, and Frederick Donovan.

ROCKETS BASKETBALL TEAM, 1953. This West Brookfield team played in the town hall. Pictured, from left to right, are (first row) Edward Snyder, Norman Griffin, Harold R. Chesson, and Frederick Hamel; (second row) George Gilman, George Wirf (manager), Jerald Pratt, Francis Bugbee, and Robert Benson.

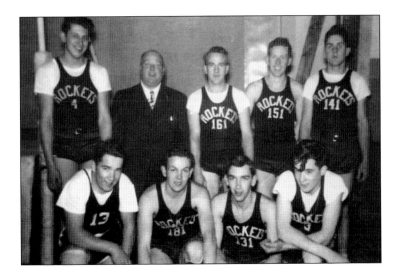

39

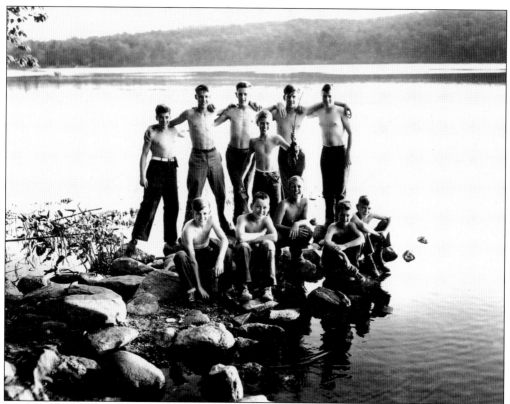

BOY SCOUTS, 1953. The Boy Scouts of America promote educational activities and lifelong values with fun. The Scouts of Troop 118 spent a day fishing on Lake Wickaboag. They are, from left to right, (first row) William Mathieson, Douglas White, Blaine Potter, Robert Iott, and Carl Mathieson; (second row) William Anderson, Peter Smith, William Jankins, unidentified (holding fish), James Thurber, and James Cobb.

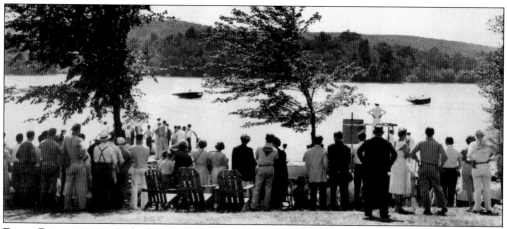

BOAT RACE, 1947. Onlookers watch tensely as three Chris-Crafts compete on a Sunday afternoon. Harry Bousquet is on the judge's stand in white. Palmer Carroll, competing in a 16-foot, 95-horsepower Chris-Craft, placed first. Arthur Tolman, in a 17-foot, 95-horsepower Chris-Craft, placed second. Not shown is Jesse White, in a 17-foot Ventor, who placed third. (Photograph by Leslie Campbell.)

Four

Town Departments and Businesses

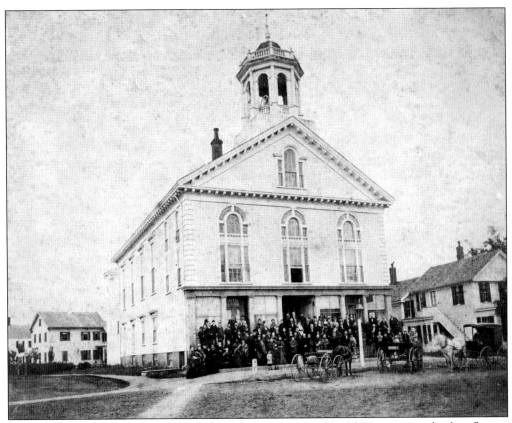

West Brookfield Town Hall. Built in 1860, the town hall had businesses on the first floor, a large hall and town offices on the second floor, and the town library in the attic in 1874. In 1888, a lockup was installed in the basement. In the late 1890s, the Bay State Corset Company rented space for its many employees. The employees are shown here, around 1900, on the front steps.

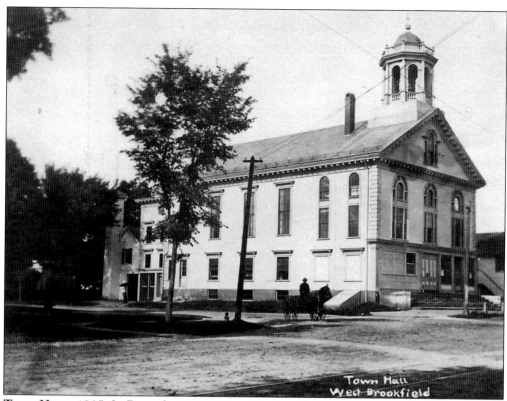

TOWN HALL, 1905. In December 1904, Henry Spaline, the state inspector of public buildings, declared the town hall the "worst kind of fire trap." He closed the second floor until a second exit could be installed, as well as decent sanitary facilities. To minimize revenue loss, the update was quickly voted, approved, and completed by October 1905, including newly installed electricity. A dedication ball was celebrated in November 1905.

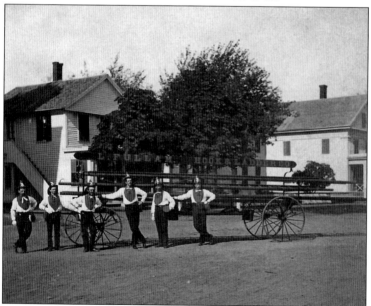

LEMUEL FULLAM HOOK AND LADDER. In 1874, Lemuel Fullam gave the town this hook and ladder truck as well as a building behind the town hall in which to store it. This vehicle appeared in numerous town parades, including the 1910 and 1960 parades. Pictured, from left to right, are David Lincoln, Alfred Nichols, Philander Holmes, Louis Carter, Addison Beale, and foreman Frank Greene.

AMERICAN STEAMER COMPANY. At right is an original invitation to the American Steamer Company's first concert and ball, held in February 1889. The order of dances was filled with a combination of quadrilles and contras. More than 20 aides assisted John G. Shackley with the organization of this successful event. Below, a 5th-class Silsby steam engine rotary pump, shown in front of the library, was purchased in 1888. The town approved this purchase after the engineers who accompanied the steamer demonstrated 1,500 feet from the water source, with 125 pounds of steam; water from a one-inch nozzle played a steady stream over the town hall bell tower. This engine was renovated in 1906, almost 20 years later. (Below, photograph by Charles H. Clark.)

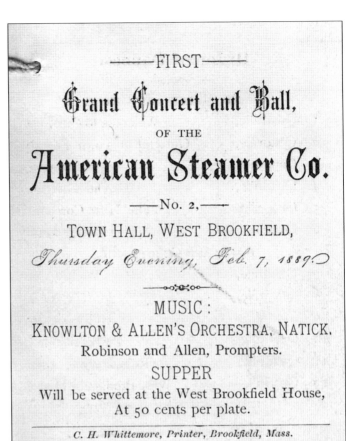

----FIRST----

Grand Concert and Ball,

OF THE

American Steamer Co.

----No. 2,----

TOWN HALL, WEST BROOKFIELD,

Thursday Evening, Feb. 7, 1889.

∘⟶◦⟶⊱⋇⟨◦⟶∘

MUSIC:

KNOWLTON & ALLEN'S ORCHESTRA, NATICK.

Robinson and Allen, Prompters.

SUPPER

Will be served at the West Brookfield House,
At 50 cents per plate.

C. H. Whittemore, Printer, Brookfield, Mass.

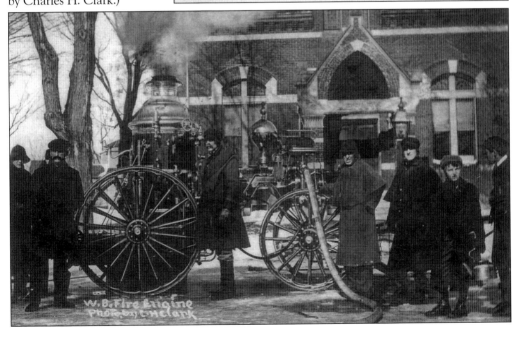

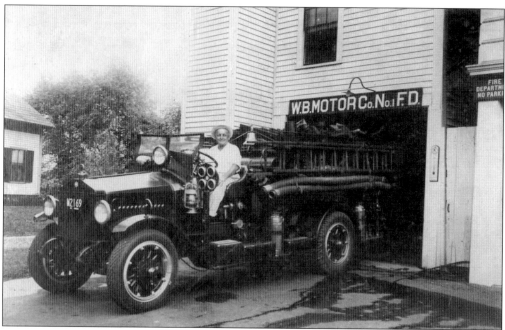

West Brookfield Firehouse. In 1905, the town hall was updated for $3,500 due to a failed fire safety inspection; the fire station was rebuilt behind the town hall on Cottage Street. Above, William Boothby was the driver of the 1924 Maxim for the West Brookfield Fire Department. In 1931, the town purchased an electric fire siren for $600 to replace the cumbersome ringing-bell system. The 385-pound siren was located on the flat roof of the new addition. Below, from left to right around 1930, are (first row) John Wirf, David Robinson, Peter Brady, William Boothby, Milton Griffen, Chief Ralph Allen, Frederick Dwight, William McCuin, Ernest Witcome, and Robert Weare; (second row) Omer White, Harold Richards, Peter Parker, and N. Perry; (third row) Walter Wirf, Leon Adams, Charles Mitchell, Walter Potter, and Edward Lucius. Officers are designated with a double row of buttons on their uniforms.

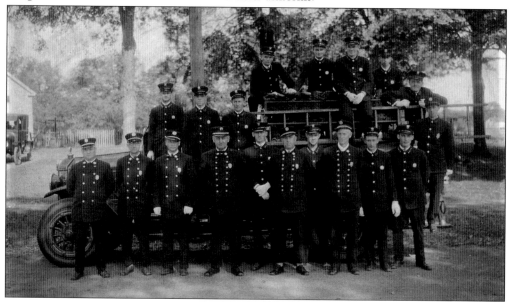

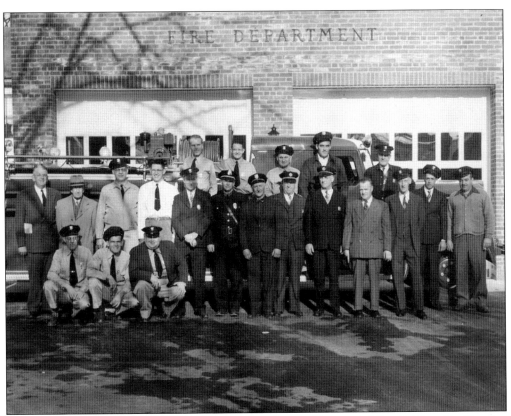

NEW FIRE STATION, 1952. Kneeling, from left to right, are (first row) Allan Stirling, Paul Lucius, and George Wirf; (second row) Percy Cregan, David Robinson, George Gilman Sr., George Gilman Jr., Morton Sampson, Peter Brady, Arthur Parker, Ralph Allen, Hudson Bennett, John Wirf, Horace Parker, Richard Parker, and Elmer Vezina; (third row) Joseph Ellis, Noel Waldo, Leon Adams, Louis Rooney, and Edward Lucius.

Mr. *Joseph Blair*

To the BROOKFIELD WEST PARISH AQUEDUCT COMPANY *Dr.*

For one Run of Water *from Apl 1 to Sept 30-1846 6 Months*, at 50 c. $ 3 = 00

Brookfield, *Oct 1-* 1846

Received Payment,

HARRISON HATHAWAY, *Treasurer.*

BROOKFIELD WEST PARISH AQUEDUCT COMPANY. Three private water companies supplied water to West Brookfield in 1846. Harrison Hathaway, treasurer of the water company, signed a receipt for the residence of Joseph Blair for one run of water from April to September 1846 at the cost of $3. The Brookfield West Parish Aqueduct Company piped water to the center of town from Long Hill. The late 1880s saw many dissatisfied customers.

45

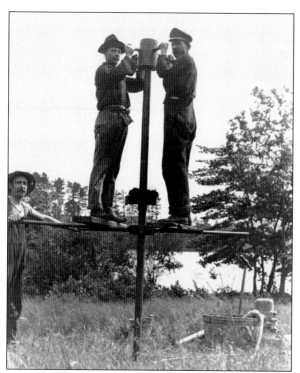

DRILLING FOR WATER, 1912. From 1893 to 1911, voters debated a town water system; a drought from 1904 to 1908 prompted many heated discussions. The water commissioners ordered wells dug to find the best resources. One worker walks the spoke around as the other two workers pound constantly on the drill to get to the water source. Permanent wells were dug at the south end of Lake Wickaboag.

RESERVOIR UNDER CONSTRUCTION. A public water supply system was approved in 1913. The water department began work on the covered concrete reservoir, located on Long Hill, in the spring of 1913. The reservoir was designed to hold 225,000 gallons. Water was pumped from the pumping station surrounded by four acres of land formerly owned by Joseph Clark.

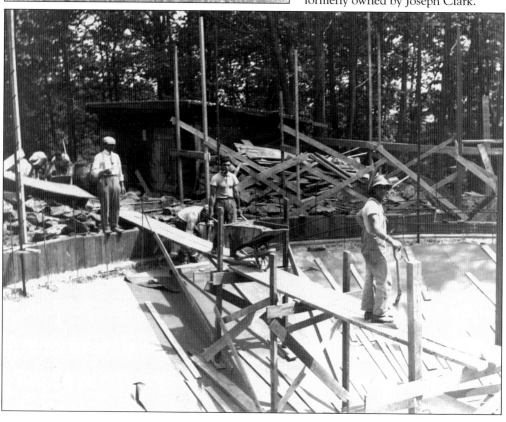

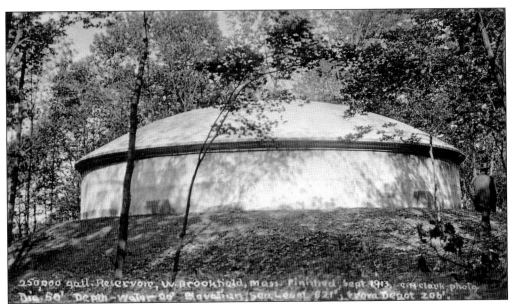

250,000 gall. Reservoir, W. Brookfield, Mass. Finished, Sept 1913. c.m.clark photo. Dia. 60' Depth - Water 20' Elevation, Sea Level 821' from Depot 206'.

COVERED CONCRETE RESERVOIR. The water was pumped to the reservoir from a well located at the south side of Lake Wickaboag with a 25-horsepower Rumsey, with a capacity of 250 gallons per minute. A May 1913 bid proposed using 380 cubic yards of American Portland cement concrete in the circular wall and 200 lineal feet of three-inch drain pipe in place on the bottom.

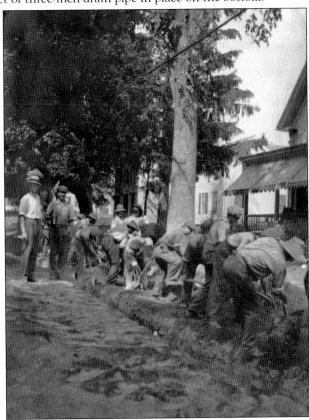

LAYING WATER PIPES. Opposition from the outlying farmers who would not benefit from a water system was the main reason behind delayed system installation approval. The approved vote was met with great fanfare by those in the town center who wanted this system. In the summer of 1913, sixty to seventy-five men from Simpson Brothers of Boston installed 6.05 miles of water pipes.

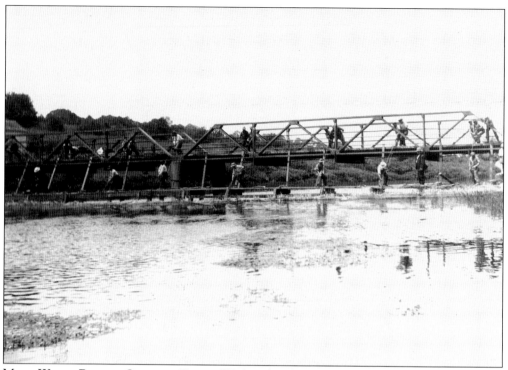

MAIN WATER PIPE ON QUABOAG RIVER. Workers lay the main water pipe across the Quaboag River from the Lake Wickaboag pumping station during the summer of 1913. For the first 23 years, Joseph E. Malloy was the water superintendent. In May 1936, Guy L. Merrill succeeded him, and Morton F. Sampson was appointed in 1941.

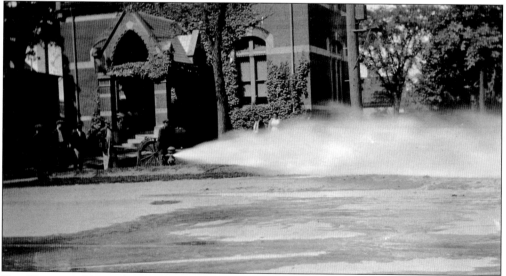

FIRE HYDRANT TEST. The new water system fed 63 fire hydrants in the center of town, including this one being tested in front of the library on the corner of Main and Cottage Streets. After reservoir construction, a major leak was discovered; contractors had to completely drain and build a new bottom in 1914. An employee had to guard the pumping station night and day to turn on the pump in case of fire.

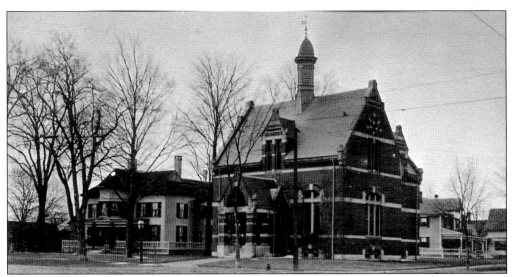

MERRIAM LIBRARY. In 1874, the Free Public Library was established in the town hall, with Thomas S. Knowlton as its first librarian. That same year, Charles Merriam more than doubled the library collection to 1,408 volumes, and Lemuel Fullam donated furniture for a reading room. In 1880, the town accepted a gift from Charles and George Merriam to build and furnish a separate library building for $15,046.

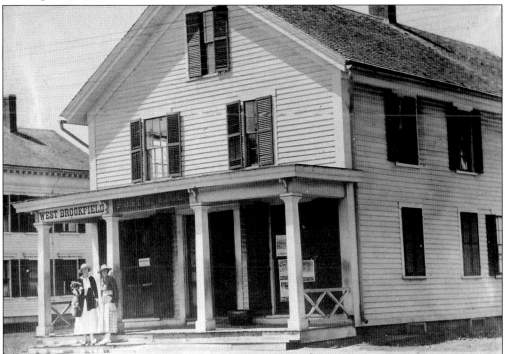

CENTRAL STREET POST OFFICE. In 1861, the post office was located on the first floor of Ezra Blair's business; he was appointed postmaster by President Lincoln. When he moved into the Blair Block in 1879, Blair brought the post office with him. Serving 36 years, Oliver Kendrick was appointed in 1885 and moved the post office to 15 Central Street. (Photograph by John Ingliss Habben, courtesy of Lindsey E. Smith Jr.)

TOWN FARM, 1910. In 1889, voters approved building a new town farm, with 21 rooms. In 1899, the State Board of Lunacy and Charity reported that the "almshouse is under good management, in good repair. Farm interests are well looked after, realized an income of $1,250 for year. There is no separation of sexes during the day, at night it is complete. There are six inmates, one of whom is insane."

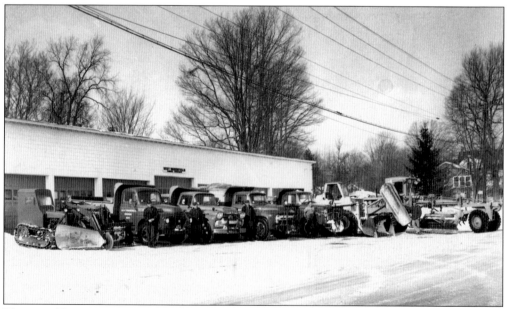

HIGHWAY DEPARTMENT, 1960. The town's road fleet found in the town report included (not necessarily all pictured here) a 1952 Ford truck, 1955 International truck, 1958 Chevrolet truck, 1956 Ford truck, 1960 International truck (purchase price for new truck, $3,990), 1958 pay loader, 1948 Caterpillar tractor, 1956 sander, and a 1955 International tractor. The highway crew, from left to right, are Theodore Prizio, Alcid Perron, Armand Gratton, George Cook, and Roger Labier.

WEST BROOKFIELD POLICE DEPARTMENT, 1960. The West Brookfield Police Association became active in 1960, assisting with the town's purchase of its first police car and radio. Seen here, from left to right, are (first row) Deputy Chief Harold Gardner and Chief John Wirf (appointed in 1959); (second row) Henry Jory, Earl Sawyer, John Zabek Jr., Walter Thompson, and Francis Frew; (third row) William Ackerman, Robert Glackner, Andrew White, Gilbert Merrill, and Laurence Wilson.

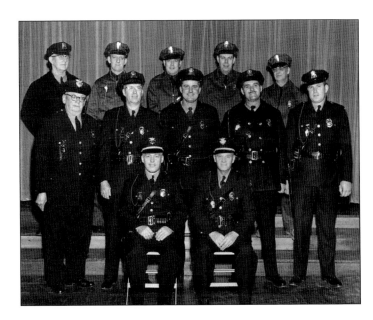

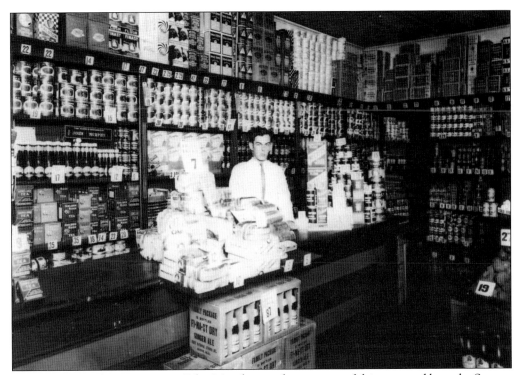

FIRST NATIONAL STORE, C. 1940. John Murphy was the manager of this store and later the Socony Gas Station. He was the first in West Brookfield to enlist for World War II, serving in the Army Air Corps. He was born in 1912, the only son to Edmund and Margaret Murphy, graduated high school in 1931, was married to Bertha Winifred Bristol for 46 years, and had two daughters.

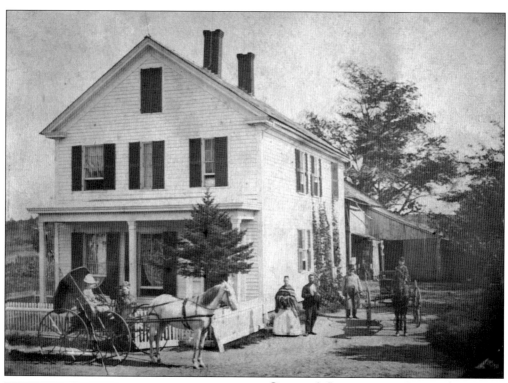

GLEASON'S LIVERY, 1893. Lewis Gleason ran this livery on High Street for many years, as well as a stage line between North and West Brookfield, which appears on the 1870 Beers atlas. His livery ran in connection with the Wickaboag House until 1876, when the North Brookfield rail spur opened. Sisters Helen (left) and Myrtle Dodge, both active in the community, pose in front. The livery is currently a private home.

WICKABOAG HOUSE,
H. W. HOLT, PROPRIETOR,
Located near Depot, West Brookfield, Mass.

L. Gleason's Livery and Feeding Stable in connection with the house.

WICKABOAG HOUSE. Built in 1852 by George Crowell at the corner of Sherman and Central Streets, the Wickaboag House was the closest hotel to the busy railroad depot and subsequently very successful. Three different owners managed this hotel until 1890, when it was destroyed by fire. In 1914, the barn was moved to Naultaug Brook Farm on Bridges Road.

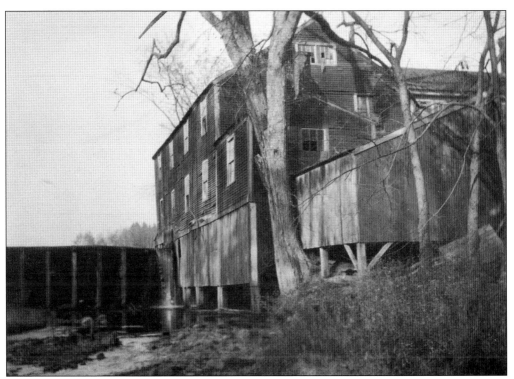

TYLER'S MILL. Established by George Tyler in 1849, this small sawmill was upgraded to include a gristmill and then a turbine. This is the dam with no water flowing and the overshot waterwheel on the right. The site of many local social activities, the mill was located on Mill Brook off Wickaboag Valley Road. The Tyler family operated the complex until 1915, when it was sold to Arthur Gilbert.

CAMP WICKABOAG
FOR BOYS

EIGHT TO FIFTEEN YEARS, INCLUSIVE
JUNIOR AND SENIOR GROUPS

*Combining the Educational and Character-Building Features
of Farm Life with All that is Best in the Highest-
Grade Recreational Summer Camps*

DR. ARTHUR W. GILBERT, *Director*

WEST BROOKFIELD, MASSACHUSETTS

CAMP WICKABOAG. In 1927, Dr. Arthur Gilbert, state commissioner of agriculture, opened this camp for boys at the former Tyler's Mill. The 400-acre camp was designed to serve well-to-do families from New York and Boston. Young boys experienced horseback riding, fishing, swimming, marksmanship, and scientific agriculture, and used sawmill equipment to make small racing sailboats. An eight-week stay cost $300; for the same amount, one could purchase a Ford Model T.

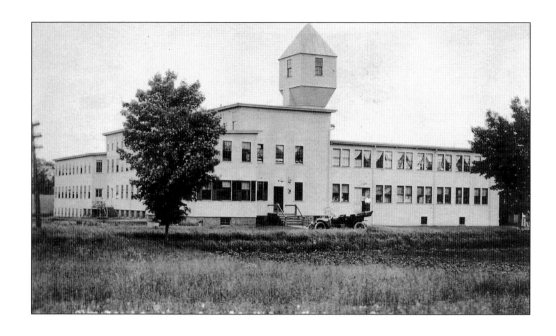

QUABOAG CORSET FACTORY, 1915. The West Brookfield Builders Association built this Pleasant Street factory (above) for $10,095, to rent to Chauncey Lockhart Olmstead, a previous owner of Bay State Corset Company, destroyed by fire in 1886. The factory opened in 1894, with cutting and pressing operations on the first floor, and company offices, sample rooms, and packing and shipping departments on the second floor. A 5,000-gallon water tank was installed under the tower for the building's sprinkler system. Electric lighting was added in 1903, along with two additions for the growing business. At far right, a horse was stabled, needed for many trips to the depot to ship corsets. The top floor was a stitching room (below), where nearly 100 stitching machines on two long tables ran the length of the floor. The light from the windows was said to be perfect.

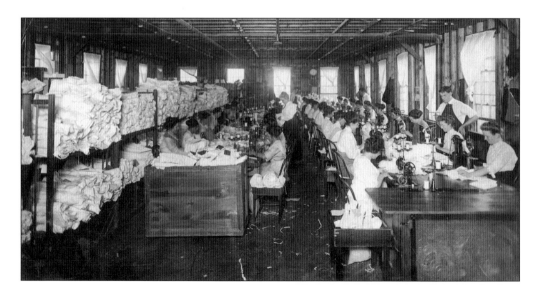

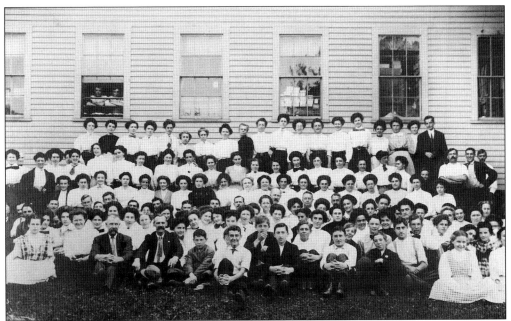

CORSET FACTORY EMPLOYEES, 1910. Chauncey Olmstead was considered a good employer in the town of West Brookfield. An instance of his kindliness appeared during the blizzard of 1897, when women who arrived at work were surprised with dinner, a social hour, and a sleigh ride to see them home safely. The factory produced 200 dozen corsets per day and employed 250 hands. (Photograph by Moon Company.)

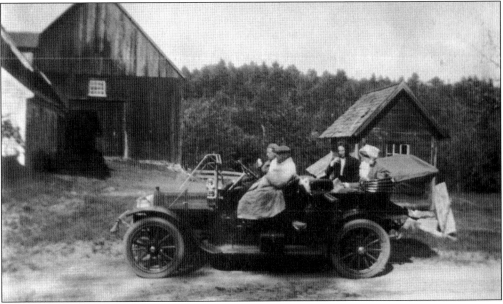

CHAUNCEY OLMSTEAD AND FAMILY, 1913. The Olmstead family's Ford Model T is loaded and prepared for vacationing near Boston. Chauncey Olmstead was born in Connecticut in 1830 and began his career in New York in 1859, creating custom corsets. In 1879, he was superintendent of the Bay State Corset Company, and he became the owner in 1885. In 1915, he passed away at the age of 85 in his home next to the public library.

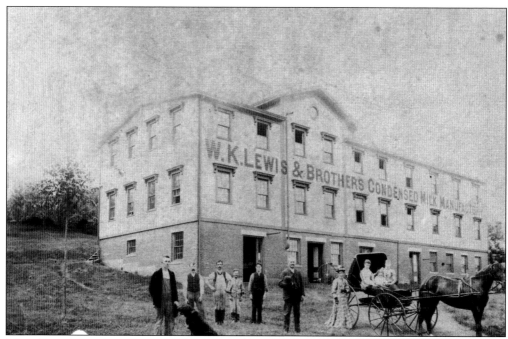

MILK FACTORY, 1891. Pictured above are, from left to right, George Knowlton, Jack (dog), Clayton Clark, Mr. McGreary, Mr. Sholes, Mr. Brother, Charles Knowlton, Gina Hocum, Jennie Knowlton, Clarence Hocum, and Lyddie Knowlton. Located south of the river, Lewis Brothers of Boston opened the factory in 1863, producing cheese, butter, and Eagle brand condensed milk under agreement with Borden. The process preserved milk for long periods, ideal for travel or military use. When West Brookfield farmers could not provide enough milk, other towns were invited to deliver, lining up on Milk Street. The c. 1900 view of the town below was taken from Warfield Road (named after distinguished World War I sergeant Arthur Warfield) and shows the tall chimney and surrounding roofs of the milk factory in the foreground. The large four-story building at right is the former Allen and Makepeace Shoe Manufacturing, the current site of the senior center.

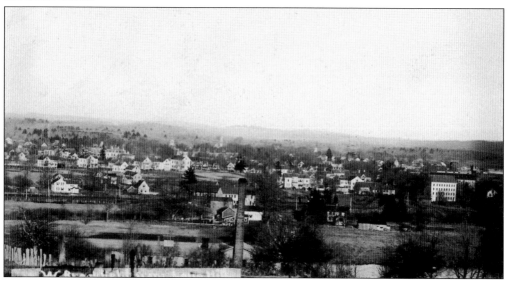

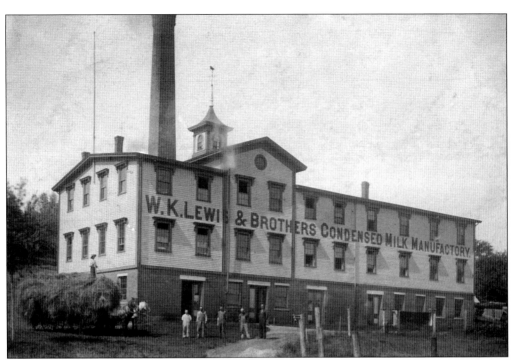

W.K. Lewis & Brothers Factory, 1893. In 1895, operation of the factory was sold to Boston Condensed Milk. By 1897, local farmers were due over $7,000, and they started selling to C. Brigham and Company, as it shipped from the depot. When Boston Condensed started purchasing from C. Brigham, paying Boston prices, it was given a court order to cease and desist, then proceeded to negotiate with the farmers, settling on 70¢ on the dollar. Boston Condensed closed in 1898. The factory sold to C. Brigham a year later but closed in 1901, before being destroyed by fire in 1910. In 1915, the 100-foot brick chimney was dynamited, and the remaining barn burned in 1916. (Above, photograph by Alvah W. Howes, courtesy of Joseph Shepard.)

BOSTON CONDENSED MILK COMPANY.

FACTORY:		OFFICE:
W. BROOKFIELD, MASS.		7 EXCHANGE PLACE, BOSTON, MASS.

TELEPHONE, 313-3 CHARLESTOWN.

We supply the Cunard, Savannah, and Fruit Steamship Lines.

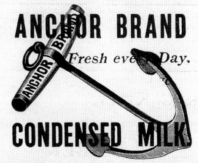

ANCHOR BRAND CONDENSED MILK is made from pure milk (the product of the choicest stock fed upon the Berkshire Hills), delivered fresh daily at our factory, and the best refined sugar. Our daily output averages 300 ten-quart cans. It is admirably adapted for all culinary and food uses, and is recommended by the best physicians as superior to fresh milk from one cow in the feeding of infants. It can be obtained from all leading grocers in air-tight glass jars. Also manufacturers of Crystal Spring Butter, sold in prints and tubs by J. GILBERT, Jr. & COMPANY, 2½ Park Square, General Agents. Telephone connection.

BOSTON CONDENSED MILK COMPANY

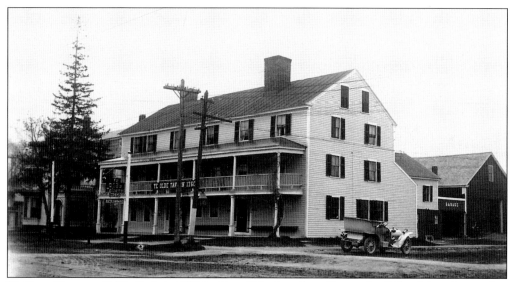

YE OLDE TAVERN, 1890. Built in 1760 by David Hitchcock and located at 7 East Main Street, this guesthouse and tavern has hosted some famous visitors. The 250-year history of guests includes George Washington in 1789 (he mentions his visit in his journal), Pres. John Adams in 1799, Jerome and Elizabeth Bonaparte in 1804, and Gilbert du Moitier, Marquis de Lafayette, in 1824. (Photograph by Eddy Make.)

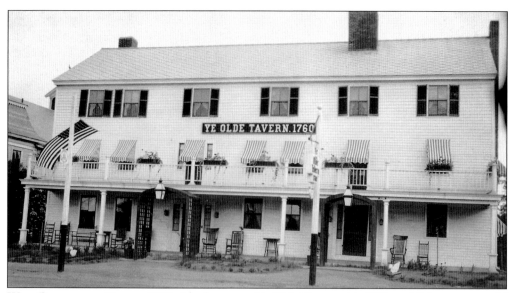

WEST BROOKFIELD HOUSE, 1910. Also known as Ye Olde Tavern, this 1760 establishment was sold at auction to hotelier David Jennison in 1905. In 1914, Elmer Huntoon purchased the property after managing it for two years. Huntoon passed away in 1918, and the tavern remained closed for over a year due to Prohibition. In 1920, Garrison Hill of Jamaica Plain purchased it, focusing on summer visitors and closing during winter.

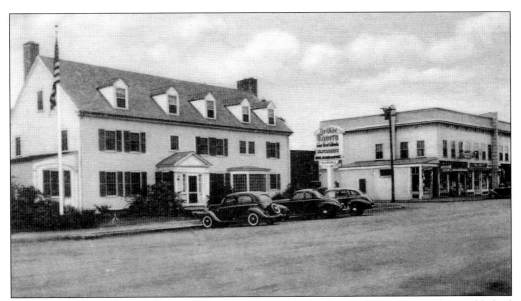

TAVERN AND CONWAY BLOCK, C. 1930. In 1928, Marion Reid owned the tavern. She established Western Union for her guests in the inn, eliminating the need to go to the depot or Worcester to send a wire. A fire in 1928 caused the interior to be gutted and both the exterior and interior to be rebuilt. During renovations, workers recovered an 1847 invitation from the Thief Detecting Society.

CONWAY AND WHEELER BLOCK GROCERS, C. 1900. Standing behind the block and Ye Olde Tavern are grocery store owners Frank Blodgett (left) and Eli Converse (center) and employee Martin Walsh. In December 1923, Walsh was appointed deputy street commissioner and drove the plow truck sent from the state to keep roads clear of snow. Walsh donated the Fort Gilbert Park flagpole in 1931. (Photograph by Charles H. Clark.)

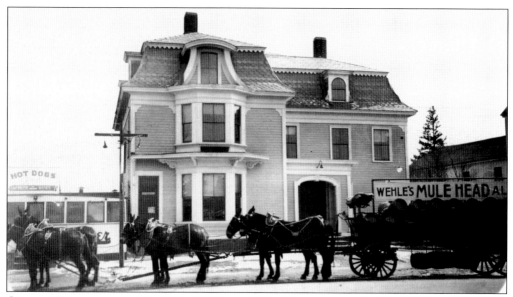

GRANGE BUILDING AND PIC HOWE'S DINER. The Grange, organized in 1889, included the Brookfields, Warren, Spencer, Brimfield, Oakham, and New Braintree. In 1920, the Grange purchased this building at 9 East Main Street; realizing members needed a larger meeting space than the house could afford, the Grange purchased the barn from the rear of the Putnam house on West Main Street and moved it to the back of this building.

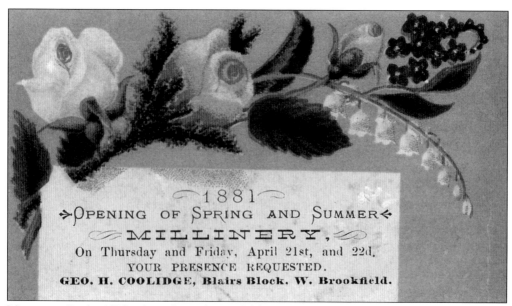

MILLINERY. In the 1880s, the only media available was print. This 1881 trade card distributed by George H. Coolidge politely invites consumers to view his spring and summer millinery lines. Other merchants in the Blair Block, located across the street from town hall—Charles H. Clark and George A. Bailey—also used trade cards extensively.

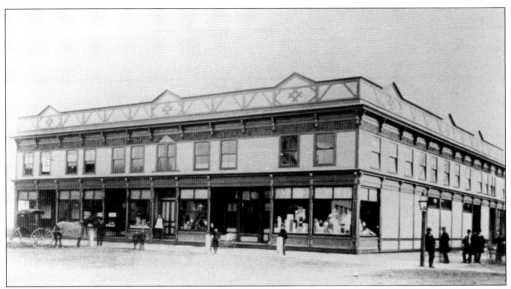

Blodgett and Converse Block, 1887. This building was constructed on the Blair Block footprint by Frank Blodgett and Eli Converse. Blodgett had previously partnered with Blair when building the Blair Block, which was destroyed by fire after eight years. This structure, in which Coolidge and Clark had again rented, was destroyed by fire after five years. The adjoining Maynard Building was also completely destroyed.

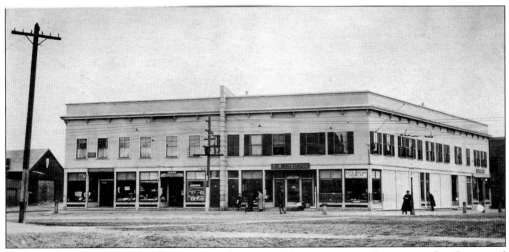

Conway Block, 1893. John Conway, not discouraged by two previous fires, immediately erected another two-story building at this location, with a cement block firewall dividing the structure. Carl Wheeler partnered with Converse in the general store. There were seven residential apartments on the second floor. In February 1931, a fire on the second floor destroyed the left side of the building; the firewall saved the right.

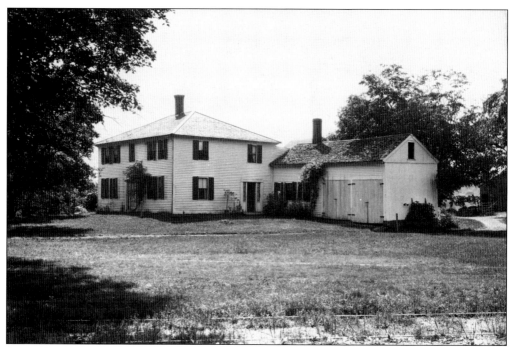

SALEM CROSS INN. Start with a run-down farmhouse, add imagination and six years of hard work, and the results are an amazingly beautiful colonial restaurant recognized throughout New England (above). Arthur Salem purchased this property in 1952; his son Richard wanted to restore it for a family home. Brothers Henry, Robert, and Ernest promised to help with the 1720 farmhouse. George Watson, former superintendent of construction at Old Sturbridge Village, became an advisor for the technical aspects. Soon, the plans changed from a private home to a restaurant. Work became an obsession, and the family's every spare moment was consumed by this project. In 1960, the restaurant opened for business and has remained one of the finest restaurants in the area. Below are Kenneth Salem (left), Richard Salem (center), and Henry Salem.

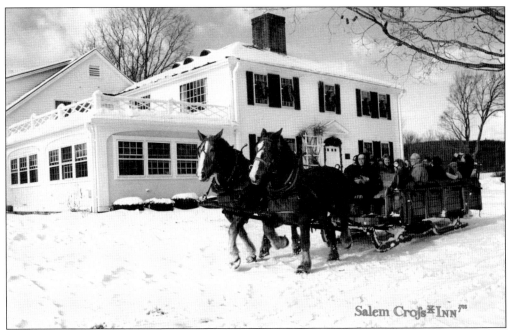

SLEIGH RIDES. Seasonal sleigh rides are provided at the Salem Cross Inn. Driver Kenneth Lane lived and stabled his horses, Harry (left) and Maple, on Town Farm Road in Brookfield and was available to arrange this service for patrons of the inn during the 1990s. Following this brisk air experience, guests may have enjoyed a hot toddy in front of an open fireplace. (Photograph by Robert Harbison.)

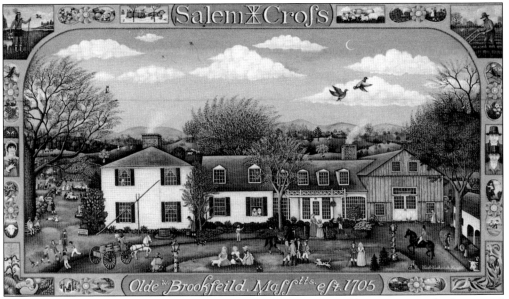

JACOB KNIGHT. Guests entering the Salem Cross Inn are greeted by an oversized oil-on-wood folk art depiction of the inn surrounded by many guests. The colorful work by famous local artist Jacob Knight will captivate the interest and imagination as one attempts to identify the hidden witches and social gatherings featuring the Salem family. An adjoining wall features another Knight painting illustrating the 1675 siege of the original Quaboag settlement.

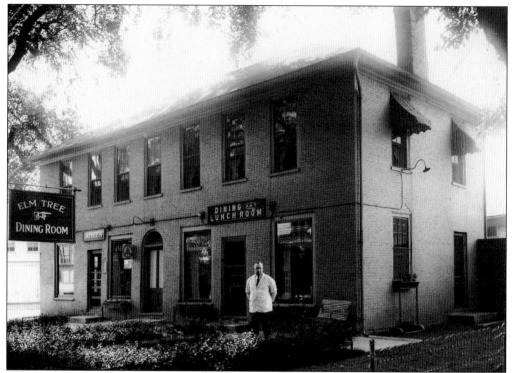

ELM TREE DINING ROOM. Elizabeth Joyce purchased this building in 1922 from Charles Risley for $4,500. In 1919, she opened Elm Tree Dining after purchasing the business from Warren Bell; the building is currently home to the Country Bank. William Joyce (center), a nephew, assisted in running the restaurant; he passed away at age 53 in 1941. Joyce then closed the restaurant and ran a rest home, selling the building in 1949 for $11,500.

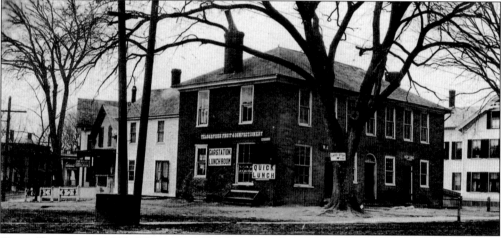

QUICK LUNCH, c. 1910. This pre-1800 Moses Hitchcock building was occupied by various printers, including Charles and George Merriam of *Merriam-Webster Dictionary* fame. Upon Noah Webster's 1843 death, the Merriams purchased the rights, publishing $6 dictionaries at their Springfield firm. Known as the Merriam Building, it was owned in 1910 by the Augustus Makepeace Estate and housed Hop Sing Laundry, a lunchroom, and a candy store. (Photograph by Charles H. Clark.)

ALLEN BROTHERS GROCERIES AND PROVISIONS, 1914. Benjamin Paul Allen is shown here in the general store he ran with his brother Ralph O. Allen, fire chief during 1926, 1930–1932, and 1957. Located on Main Street, this building is currently occupied by Haymakers Grille. Benjamin was local historian Everett Allen's father. (Courtesy of Everett Allen.)

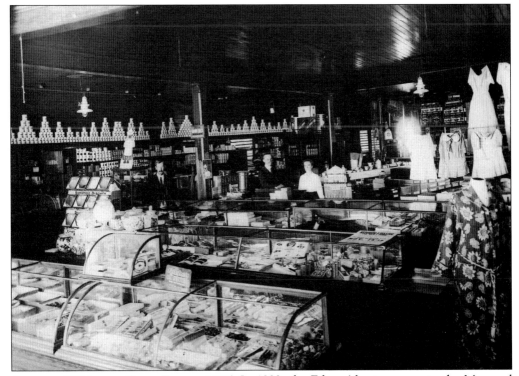

CHARLES O'M. AND CORA EDSON, 1915. In 1892, the Edsons' business was in the Maynard Building, which was destroyed during the Blodgett and Converse block fire. They rebuilt and opened in 1893. In 1913, the Edsons (center) purchased this grocery store, located in the Conway and Wheeler building, from Eli Converse. Store clerk Bert Haine is also pictured. Charles O'M. Edson was a selectman, town clerk, and state legislator.

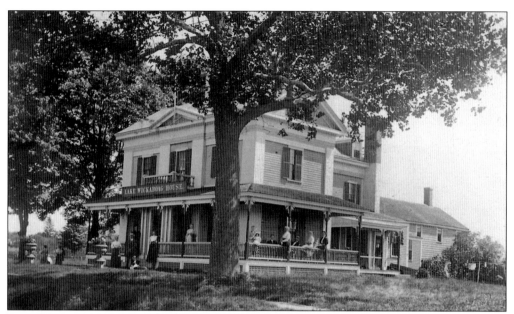

LAKE WICKABOAG HOUSE. This house on West Main Street next to the Book Bear, opened June 1, 1915, and advertised, "The house and cottages will accommodate 35 to 40 guests. Rooms are large, well furnished, cool, and clean; lighted by gas and electric lights . . . We have rooms with open fireplaces and steam heat when needed . . . There is a charming view of Lake Wickaboag . . . There is fine boating and fishing, beautiful walks and drives, large grounds with the usual outdoor attractions. Ten minutes' walk from R. R. Station; 68 miles from Boston. Worcester, Warren, and Spencer electrics pass. Terms: Per day, $1.50 to $2.00. Per week, $7.00 to $12.00. Mrs. H.H. Niles, Manager." (Photographs by Eddy Make.)

TOMBLEN'S FURNITURE. In 1839, Lucius Tomblen succeeded James Clark as a furniture and coffin maker and became the village undertaker. When Lucius died in 1863, his 24-year-old son John took over, expanding the business—located on North Main and Church Streets—to make room for retail furnishings. He split the building in two and moved each half across New Braintree Road. His home was completed in 1880 and is known as Windemere.

STANDARD FISHING ROD COMPANY. Organized in April 1900 and operating in the former McIntosh Boot Factory—purchased from the Quaboag Building Association for the manufacture of split bamboo fishing rods—the company sent its first shipment in October 1900. Apparently quite successful, the company announced in May 1905 it had received an order for 10,000 rods. In 1908, it was considering manufacturing reels; however, in October 1909, the company abruptly sold at public auction.

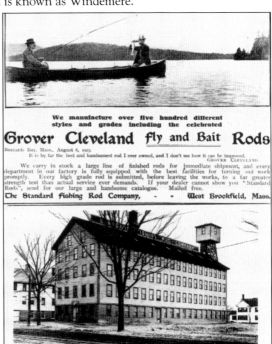

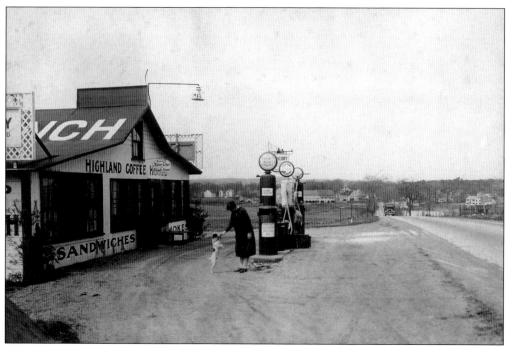

HIGHLAND COFFEE HOUSE, 1932. This small restaurant and filling station is currently the site of Howard's Drive-In. On the right, Route 9 proceeds to West Brookfield center. Pictured here, Cora E. Nutting, nicknamed "Ma," ran the business until 1937 when owner Florence Battin of Pennsylvania sold it. The large barn on the left of the road (center) was Foster Hill Dairy, owned by John Webb and later by Robert Townsend.

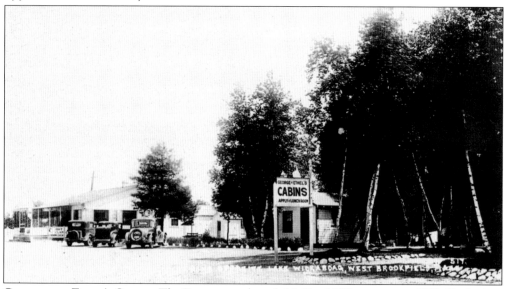

GEORGE AND ETHEL'S CABINS. The Preeces purchased this Pond Hill property in 1928. By the late 1930s, it included 29 acres and 12 small cabins—each with a modern flush toilet and coil spring mattress—and a house and restaurant (currently the Wok Inn). Renting cabins was common before the advent of motels, motor lodges, and hotels. These cabins closed before 1950; many were sold for sheds or outbuildings.

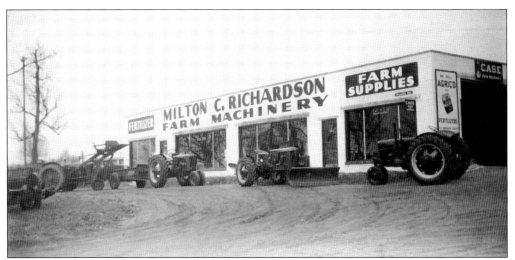

MILTON RICHARDSON FARM MACHINERY, 1947. Built by Milton Richardson, this Route 9 building served as a Case tractor franchise and sold other farm supplies. Later this building was home to the *Brookfields' Union* newspaper, Wirecraft Products owned by Walter Poti, and Quirkwire, an employee-owned facility and the current occupant. Richardson, owner of Indian Rock Farm, at times also owned a hardware store, insurance business, school bus company, and wood-shingle mill.

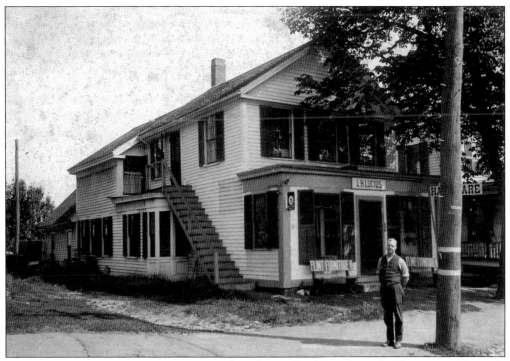

LEMUEL LUCIUS STORE, 1920s. Lucius stands in front of his Main Street hardware store, formerly part of the Classical Female Seminary and moved to its present location in 1840. The outside stairway is the only access to the second floor, although there is another outdoor stairway at the rear of the building. Other uses for this building were Dwight Fairbanks's harness shop, post office, beauty shop, and pizza shop.

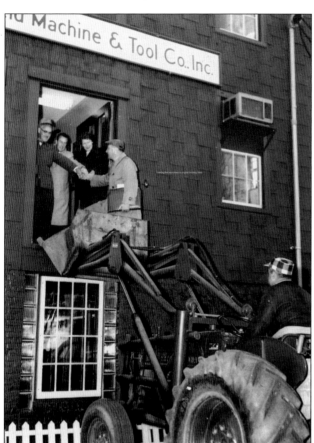

ENGLAND ARRIVES AT BROOKFIELD MACHINE, 1948. J. Irving England is lifted to his second-floor office by highway superintendent Theodore Prizio in the bucket of a town-owned tractor. England had surgery and was not allowed to climb stairs. Louis Allard (left) and Daniel Tripp (center) assisted with this unorthodox method so England could reach his office for work at 7:00 a.m. England always arrived promptly at any scheduled appointment.

BROOKFIELD MACHINE AND TOOL COMPANY, 1970. Established in 1948 in a three-story wooden building, Brookfield Machine was situated 20 years later in this modern, single-story, fireproof, air-conditioned building on Central Street, housing the most modern machine tools available. Owner J. Irving England attributed the growth and success to the craftsmen, supervisors, engineers, and employees, whose commitment established a reputation for quality. (Photograph by J. Irving England, courtesy of Roy Couture.)

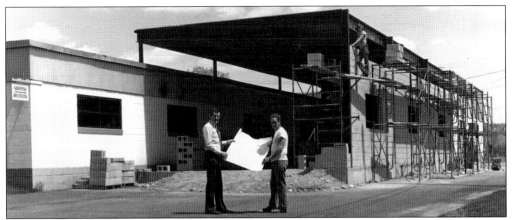

BROOKFIELD MACHINE ADDITION, MAY 1980. Vice president of Brookfield Machine Roy Couture (left) and Alvin Paquette of Paquette Masonry view building plans for an addition necessitated by growth and new equipment. J. Irving England had a philosophy that, if possible, one should use local businesses for purchases and construction. Paquette Masonry was located 500 feet away. (Photograph by J. Irving England, courtesy of Roy Couture.)

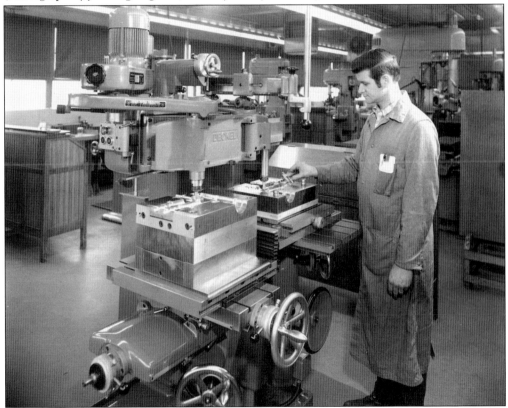

CLEAN WORKSHOP, 1971. Roger Flammand illustrates modern equipment at Brookfield Machine. Visitors could not leave without commenting on the orderly design and cleanliness of this machine shop. It was required that every workstation be absolutely clean and all tools put away at the end of the day. The cleanliness of the facility was unusual for an operating machine and tool company. (Photograph by J. Irving England, courtesy of Roy Couture.)

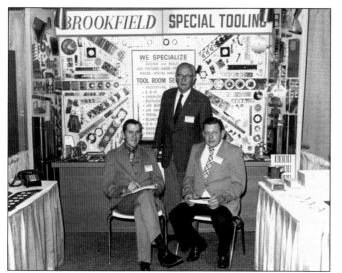

BROOKFIELD MACHINE TRADE SHOW, 1980. Roy Couture (left), vice president; J. Irving England (center), president and founder; and Kenneth David, shop supervisor, display several of the many products designed and built by Brookfield. Listed specialties included jigs, fixtures, gauges, prototype parts, molds, and special machines. England was a graduate of vocational school and state university, and he was a registered professional engineer and a licensed aircraft pilot. (Courtesy of Roy Couture.)

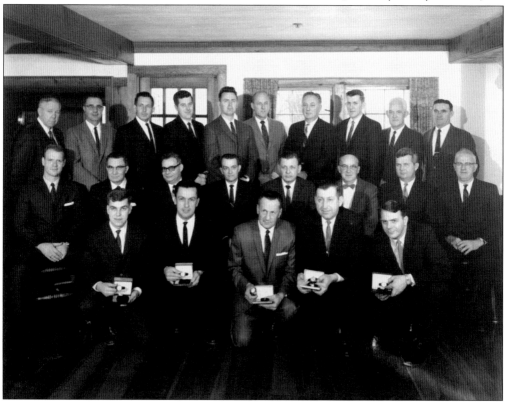

FIVE-YEAR AWARD WINNERS, 1967. Brookfield Machine presented staff with five years of service a gold watch at a dinner. Pictured are, from left to right, (first row) Harold Richards, Dale Tripp, Burt Lindenthal, Charlie Banas, and John Jacques; (second row) Richard Turnbull, Ralph Green, Ugo Salir, Cedrick Lindley, Kenneth David, Frank Sadlo, Brownie Talisman, and Warren Gresty; (third row) William McKinstry, Leonard Musca, Robert Desitels, James Sullivan, Rudy Bukowski, Arnold Austin, J. Irving England, Roy Couture, Louis Allard, and Steven Tombor. (Courtesy of Roy Couture.)

Five

TROLLEYS, TRAINS, AND TRANSPORTATION

ROCK HOUSE PASS, ROUTE 9. Installing track heading west through the stone ledge required dynamiting at the pass. This portion of track had a long, steep slope going towards Ware. Seen here under construction in 1900, the line was still moving forward in 1901 with its own bridge over the Quaboag River for the trolley. The company had several large, unforeseen expenses in constructing this line.

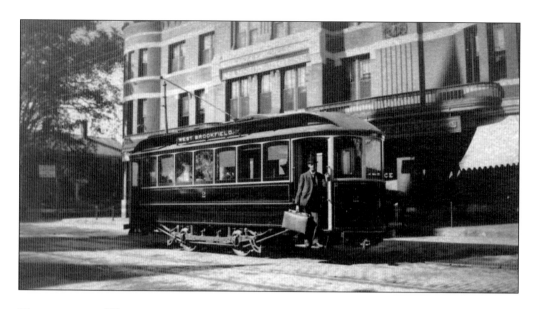

HAMPSHIRE AND WORCESTER STREET RAILWAY, 1901. Above, a West Brookfield–bound closed-car trolley with passengers leaves Main Street in Ware. Below, three conductors and passengers, in the same car as above and dressed in their finest, stop near the Rock House, heading into West Brookfield. This trolley line serviced Gilbertville and West Brookfield and was initially intended to service North Brookfield. The company purchased the 119-acre Tyler farm and constructed an amusement park with a theater and dance hall and had canoe rentals as well as steamboat rides on Lake Wickaboag. Despite their first-class construction, equipment, bright prospects, and Lakeside Park, the company failed miserably after four short years. The line shut down in 1905 due to snow and lack of coal and revenue. Lakeside Park was sold for unpaid taxes in 1905.

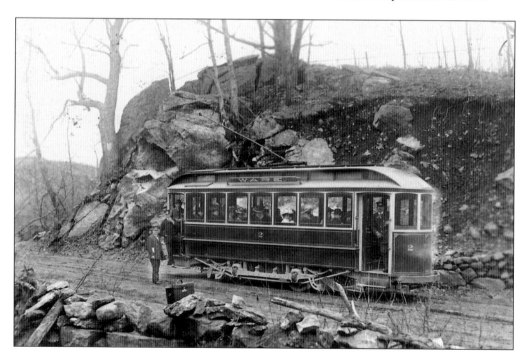

SOUTH MAIN STREET, 1910. In this view looking east towards Brookfield, the white stripe on the telephone pole at left denotes a trolley stop, with the common on the left. Oil-fueled lights line the sidewalk. In 1905, the fare between towns was raised from 5¢ to 6¢; the line was then referred to as the "Copper Line" for the bag filled with pennies the conductors had to carry for change.

WARREN, BROOKFIELD, AND SPENCER STREET RAILWAY. The railway was organized in February 1896 with capital of $200,000, and half a mile of track was laid per day by 150 men and completed to West Brookfield only four months later. This line had a long run—until 1917. Contributing factors to its closing included wartime coal shortage for power, snow-covered tracks, and a carbarn fire with estimated damages of $75,000. (Photograph by Charles H. Clark.)

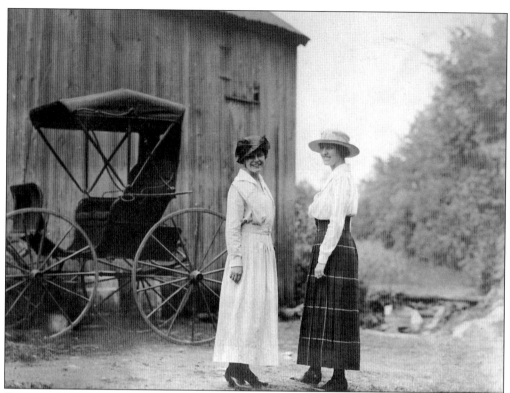

GOING TO TOWN, 1919. Marjorie Smith (left) and Jeanne Habben pose in front of the Smith barn on North Main Street (above) and inside the horse-drawn vehicle with convertible top (below) that conveyed them on a trip around West Brookfield. The Habbens were visiting from New York City. Their trip around town included, among other stops, a visit to the post office and Fort Gilbert and a ride to Chapman's Beach to view the new cottages available for rent. The blanket laid across their laps protected their clothing from the road dust. (Photographs by John Ingliss Habben, courtesy of Lindsey E. Smith Jr.)

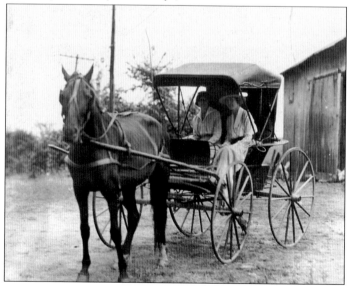

HORSE AND BUGGY WITH FAMILY, C. 1919. A family in its Sunday best, with a protective lap blanket, poses at the corner of East Main and Maple Streets. The common is on the far right; the 1830 home in the center now belongs to William and Louise Jankins, who purchased it in 1967 from Elizabeth Joyce. The shed on the left is at the end of the late Dr. Louis Roy's driveway.

BROOKFIELD, 3 MILES. Local atlases by F.W. Beers (1873) and L.J. Richards (1898) provided street and homeowner information, but the most accurate way to navigate in the 1900s involved the Post Road markers and local knowledge. These 1919 signs sit at the head of the common and in front of the Classical Female Seminary (center), established in 1825 by Reverend Foote. (Photograph by John Ingliss Habben, courtesy of Lindsey E. Smith Jr.)

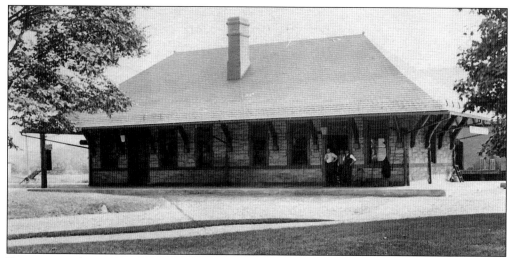

BOSTON AND ALBANY DEPOT. Gentlemen wait at the depot, located on Front Street, for the next train of passengers and goods. Constructed with Longmeadow granite with a tentlike roof, this is the third structure to serve as the depot and opened in 1885. The total construction cost was $6,000. This building currently houses the Quaboag Historical Society and Museum. (Photograph by Charles H. Clark.)

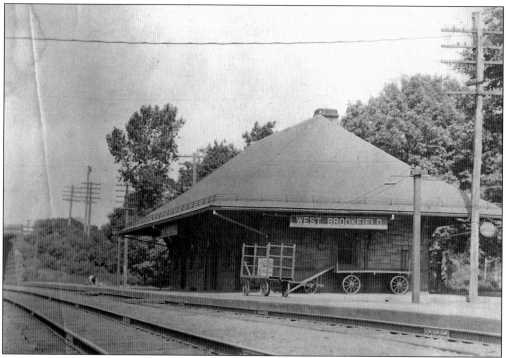

WESTERN RAILROAD, 1919. The Boston to Albany railroad was incorporated in 1833, and construction began in 1836. The first train from Worcester to Springfield was in 1839. This service was extremely important to West Brookfield, as the surrounding communities to the north had no rail service for passengers or commodities. Residents from North Brookfield, New Braintree, and other towns traveled by stagecoach for this service. (Photograph by John Ingliss Habben, courtesy of Lindsey E. Smith Jr.)

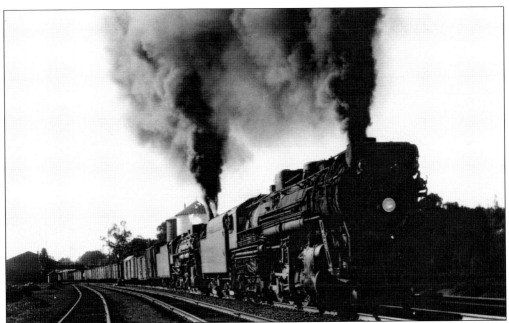

FREIGHT CARS, 1935. Eastbound from West Brookfield pulling 104 freight cars, engines 1419 and 1452, both 2-8-4 Berkshire locomotives, define the power available to steam locomotives. Designated as class A-1 in 1925, these heavy-duty machines were used by many railroad companies, including Boston and Albany. This company owned and ran 55 Lima Berkshire powerful steam locomotives. (Photograph by H.W. Pontin.)

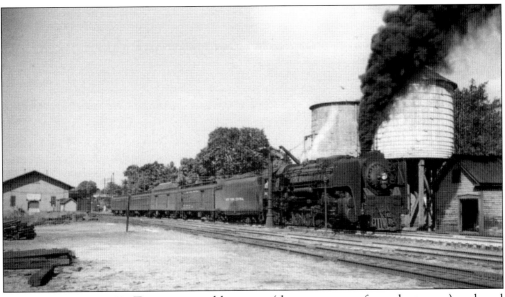

WATER TOWERS, 1940. Trains powered by steam (the water came from the towers) and coal produced cinders from the smokestacks; two long and two short blasts from the steam engine signaled the end of cinders, and laundry could then be hung out. The last steam locomotive passed through West Brookfield in 1951, when modern diesel engines took over. Shipping men and supplies during World War II prolonged its demise. The depot closed in 1956.

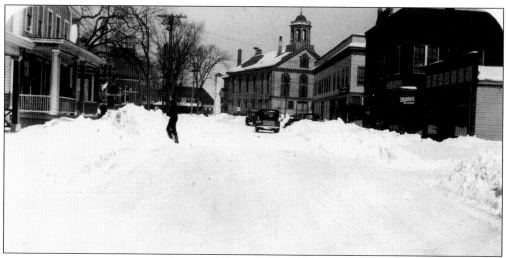

CENTRAL STREET. Snow removal in the 1930s was not defined by today's standards; due to lack of equipment, the snow was moved with plows and piled up, reducing mobility and access to buildings. The first plows were provided by the state in 1923. Snow provided a means of moving heavy loads by sleigh; the snow was packed down with rollers and shoveled into the covered bridges to enable moving these loads. Snow removal was introduced in the 1950s.

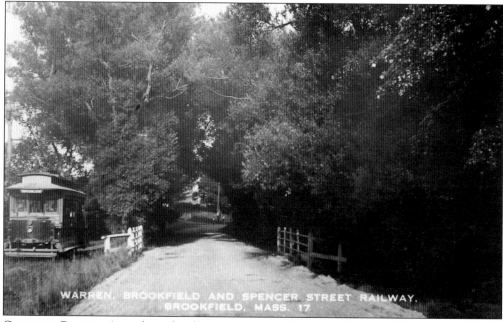

CEMETERY CORNER. A westbound trolley crosses Hovey Brook, heading into West Brookfield next to Route 9. This area was referred to as Cemetery Corner because the road had a sharp curve and was the scene of many motor vehicle accidents. The trolley company was responsible for building its own bridges over waterways; it could not use town-owned bridges.

Six

PEOPLE, HOMES, AND FARMS

FORBES HENSHAW. Forbes, son of Nellie Lawrence Henshaw, strikes a proud pose with his calf Baba. In 1907, Forbes sent this photograph as a postcard to his friend David Lawrence of Brimfield, to wish him a Merry Christmas. The Henshaw Farm was located on Warren Road and boasted the largest barn in the area; the property bordered the Quaboag River. (Photograph by Charles H. Clark.)

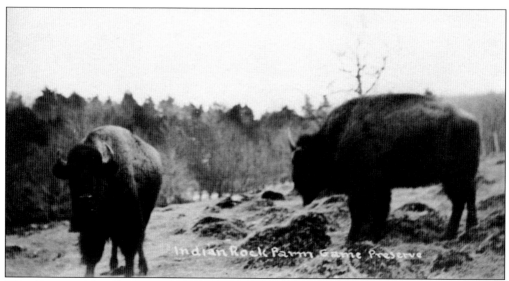

"The Buffalo Man." From 1898 to 1938, Carlton D. Richardson raised and sold buffalo, elk, and deer for public parks. West Brookfield wild buffalo were shipped as far as New Zealand and South America. The price for a little one was $50, and a large buffalo was $300. The demise of Worcester County's most unique industry on the 45-acre preserve on Foster Hill was the destruction of the eight-foot fences by the 1938 hurricane.

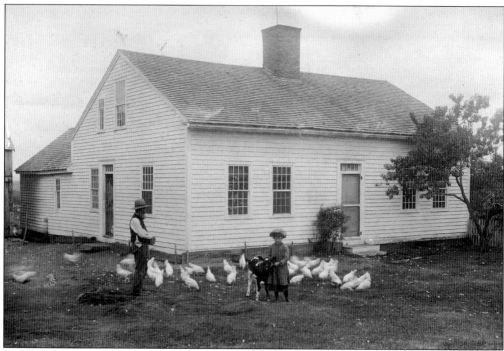

Wood Farm, 1893. Charles W. Wood (left) feeds chickens in front of his Woods Road homestead with an unidentified youth holding a calf. Assessors' records indicate he had cattle and 90 fowls on his 150 acres. The farm and other assets were taxed at $41.69 in 1893. This home today is easily identified, as there have been few structural changes over the years. (Photograph by Alvah W. Howes, courtesy of James Buzzell.)

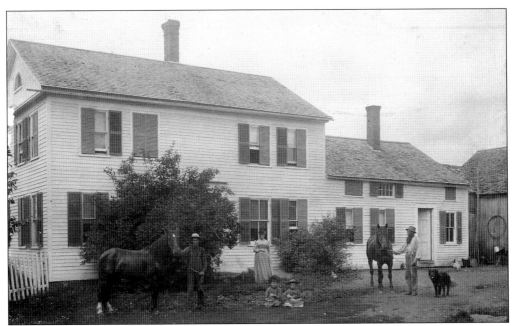

PROUTY FARM, 1893. Charles R. Prouty had 3 horses, 17 cows, and 80 fowls on 95 acres; with his house valued at $700 and barn at $400 in 1893, he paid $57.97 in taxes. Today, this Prouty Road property remains as seen here, one of the few farms in West Brookfield still recognizable today in a photograph over 120 years old. (Photograph by Alvah W. Howes, courtesy of James Buzzell.)

IDLE HOUR HOUSE. Built in 1871 and located on West Main Street, this 14-room house was purchased by Charles E. Chapman in 1915 and sold in 1939 to George Navickas, the owner of Ye Olde Tavern, who used it to house his staff and members of the tavern's floor show. In January 1940, a fire destroyed the house and barn, forcing residents to flee into the cold.

KORNERWAYS HOUSE, 1919. Located between Wigwam Road and North Main Street, this home derived its name by sitting cornerways to both streets. The front of this home may have been on a stage road to Barre, long since discontinued. Built in the 1700s, Kornerways housed several generations of the Smith family, and 250 years later it is still recognizable. (Photograph by John Ingliss Habben, courtesy of Lindsey E. Smith Jr.)

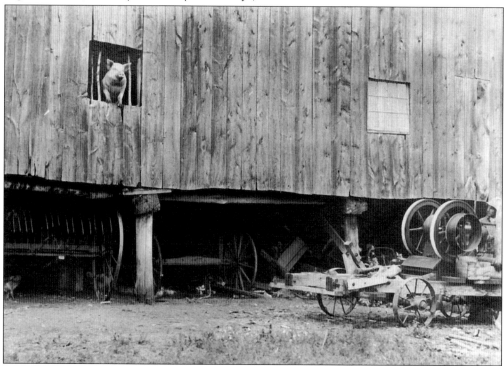

PIG HAS A VIEW. Penelope the pig observes farm activity from her bedroom window in 1919. Lindsey E. Smith Sr.'s North Main Street barn, located on the current site of the Purple Onion, was destroyed by lightning in 1933. Penelope was not in residence at the time; however, many pieces of farm equipment were lost, including a 1927 truck. (Photograph by John Ingliss Habben, courtesy of Lindsey E. Smith Jr.)

SMITH DRIVING TEAM WITH SAW RIG. Lindsey Edmund Smith Sr. and a team of horses transport a saw rig, a familiar sight in the early 1900s, as wood was the primary source of cooking and heating. Saw rigs with one-cylinder hit-and-miss engines could be heard throughout the community in late summer and fall cutting wood to stove length. (Photograph by John Ingliss Habben, courtesy of Lindsey E. Smith Jr.)

TOWNSEND FARM, 1960. In 1943, Clinton L. Townsend purchased this farm, located at 85 East Main Street, from John H. Webb, who had owned it for 48 years. Webb served as town treasurer and a fire engineer, and he was also the fire warden and the overseer of the poor. The farm buildings were destroyed by fire in January 1969. Townsend served on the West Brookfield Elementary School building committee in 1951.

BERRY PICKING, 1919. Marjorie Smith (left), sister of Lindsey E. Smith, of the Old Smith Farm (Kornerways House), accompanies Molly Habben (center) and Jean Habben as they pick berries along meadow lanes. The Habbens were from New York City and visited West Brookfield for a summer vacation, staying on the Smith farm and exploring the countryside. (Photograph by John Ingliss Habben, courtesy of Lindsey E. Smith Jr.)

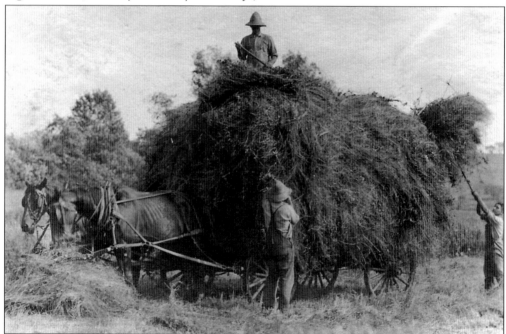

HAYING ON THE SMITH FARM. Harvesting hay with hand-powered tools—scythes and hayforks—was a quiet art. Harvesters made themselves available to be hired out during this sometimes peaceful process. Hats and shirts were worn to protect from sunburn. Coupled with the horse-drawn wagon, harmony prevails. (Photograph by John Ingliss Habben, courtesy of Lindsey E. Smith Jr.)

FRED SMITH FARM, 1919. This large elm tree defined the farm for many years, but unfortunately, due to the devastating Dutch elm disease, its demise was inevitable. The tree was actually across the street from the farmhouse, located on North Brookfield Road. This farm was one of the largest producers of milk in West Brookfield. (Photograph by John Ingliss Habben, courtesy of Lindsey E. Smith Jr.)

CUTLER HOUSE. This house at the corner of Cutler and Snow Roads was home to Howard Cutler, who was injured and taken prisoner in North Africa by Germans during World War II. He was carried 7 miles by stretcher and 17 by motorcycle to reach a hospital, which 2 days later was taken by the British. The first West Brookfield man to go overseas, he was also the first wounded, captured, and returned home.

ROBINA RUSSELL TUCKER, FEMALE TAXIDERMIST.
Robina Russell Tucker (pictured at left) came from Scotland to America at the age of eight, and she married Wallace Tucker in 1898. She was an accomplished marksman and the only female taxidermist in Massachusetts. Her home on Tucker Road had a museum with her specimens, most of which she harvested herself, as the animals were a detriment to local farmers. Robina passed away in 1950, and Wallace followed in 1954; the Tucker farmhouse and the taxidermy collection were destroyed by fire in 1955. In 1910, Wallace Tucker purchased stock in the West Brookfield Creamery Company, located on the south side of the railroad tracks; sadly, this was a failing business.

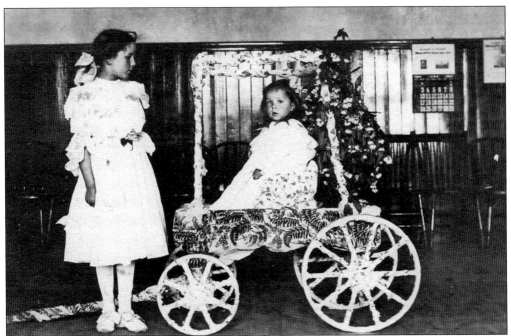

LABOR DAY WEEKEND, GRANGE PARADE. In 1922, the Grange, located on East Main Street, initiated annual field days on the common during Labor Day weekend. It started on Saturday morning with a parade and was followed by competitions amongst fire departments. The doll-carriage parade was at 3:00 p.m. and a baby (pre-school) show in the Grange at 4:00 p.m. (Photograph by Charles H. Clark.)

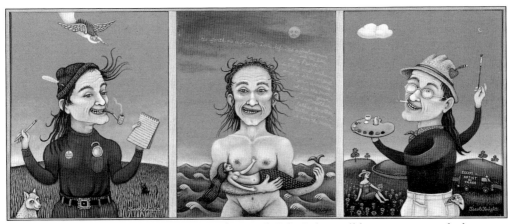

ROGER E. JASKOVIAK SELF-PORTRAIT. Nicknamed "Jake," this well-known artist took the name Jacob Knight for marketing his art, cartooning, and sign making. He lived in West Brookfield for nearly 20 years. His art covers everything from calendars, books, oversized portraits of country towns and events, and sculptures from materials he collected from the town dump, which was adjacent to his home on Wigwam Road. He died in October 1994, at the age of 56.

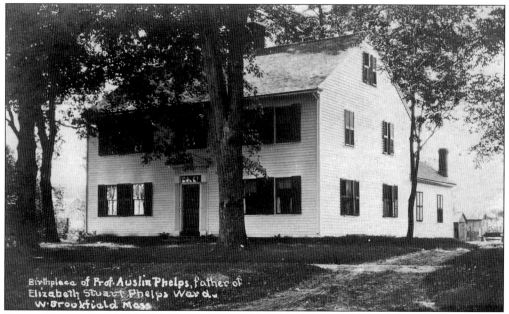

PHELPS HOUSE, C. 1890S. Clergyman, teacher, and author Austin Phelps was born in this East Main Street house in January 1820. Believed to have been constructed in 1782 by Ye Olde Tavern builder David Hitchcock, the house had 11 owners, all outstanding community leaders. One in particular was Dr. Louis Roy, family physician, historian, author, and founder of the Quaboag Rehabilitation and Skilled Care Center. (Photograph by Charles H. Clark.)

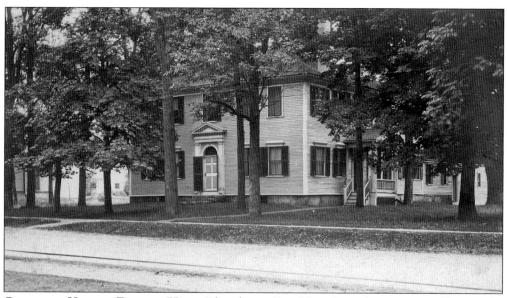

CURRENTLY VARNUM FUNERAL HOME. This elegant East Main Street home, pictured here in the 1920s, was built in 1790 by Jabez Upham. It presently is in a near-perfect state of preservation, an almost unequaled specimen of generous, beautiful, and substantial architecture built over 200 years ago. Upham, born in West Brookfield in 1764, became a lawyer and jurist representing the Worcester District in Congress from 1793 to 1804. (Photograph by Charles H. Clark.)

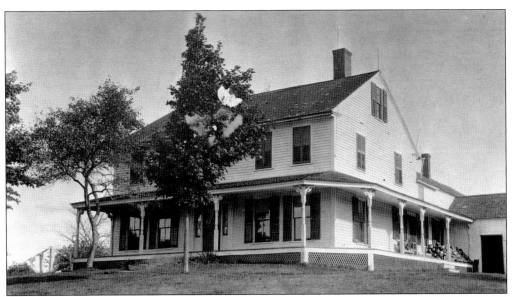

CHARLES H. FAIRBANKS FARM, 1893. This gracious home on Cutler Road is easily recognized today. The property consisted of 110 acres extending to the northwestern shore of Lake Wickaboag and included an icehouse on the lake. Three generations of the Fairbanks family occupied this property for over 70 years. Goss Garrison of Quaboag's early history was located here. Today, this farm raises miniature horses.

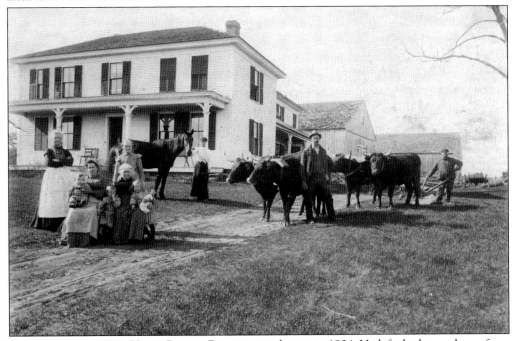

BARRETT FARM, 1905. Henry Proctor Barrett passed away in 1904. He left the house, barn, farm of 210 acres, cattle, and oxen to his wife, Celuria. Pictured here, from left to right, are (first row) Frank Barrett, May White Barrett, Luther Barrett, Celuria Barrett, and Jenny Barrett; (second row) Syshronia, Relief Ann Barrett, Annie Barrett, Henry Windsor Barrett, and a hired man. Henry Windsor was the youngest of the seven Barrett children. (Courtesy of Richard Barrett.)

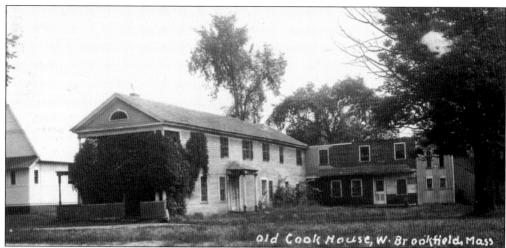

OLD COOKE HOUSE, 1915. Located on the corner of Milk and Main Streets, the larger part of this building was used as a general store and print shop and contained the post office when Samuel Stoddard was postmaster in May 1853. Purchased by Sacred Heart in 1920, part of the building was moved to Sherman Street, and the remaining part was torn down to build the Sacred Heart rectory. (Photograph by Charles H. Clark.)

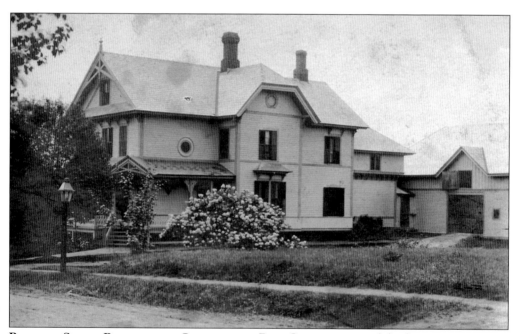

PLEASANT STREET RESTORATION. Current owner Dave Cameron restored this home to its previous grandeur. When this house was purchased in the early 1990s, it was in serious decay, with a rickety greenhouse and a sagging three-story carriage house. The remarkable Stick Style architecture is noticeable with exaggerated horizontal and vertical lines, hand-tooled details, and a facade punctuated with round and diamond-shaped windows. (Photograph by Charles H. Clark.)

Seven

RELIGION AND EDUCATION

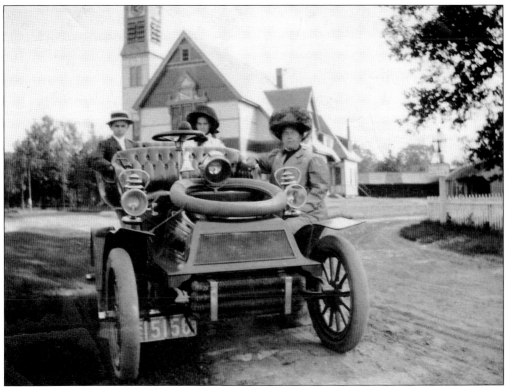

SUNDAY DRIVE, 1911. A family poses in front of the West Brookfield Congregational Church on the common, in an early open touring car. Note the carriage shed, visible at right, for church members arriving by horse and carriage. This automobile by an unknown maker has an unusual set of three headlamps and possibly right-hand steering, as well as a spare tire on the front and likely hidden work gloves and coveralls.

METHODIST CHURCH. The first Methodist services were held in 1798 on Ragged Hill by Rev. Elijah Bachelor. Local families hosted services in their homes until a church was built in 1823. The first town center services were in Pritchard's Tavern in 1840. The tavern was moved from the intersection of Foster Hill Road and Route 9 to Milk Street, where services were held on the second floor. This current church was purchased in Templeton, rebuilt at 33 West Main Street, and dedicated in October 1859. The portrait insert below shows Rev. William Mosley Jr. in 1909. The Hook pipe organ was installed in 1884 and remains an important asset to the church. Electric lights were added in 1915, and over the next two decades the horse sheds were removed to make way for automobiles.

OLD CONGREGATIONAL CHURCH. The first parish church and meetinghouse, located across the street from the common, was dedicated in 1795. In 1838, it was turned 90 degrees to the right, a six-foot extension with four pillars was added to the front, and a steeple replaced the former cupola. The 671-pound bell had been purchased from Paul Revere for $298.13; the total installation cost was $344.67. This church was struck by lightning and completely burned in February 1881.

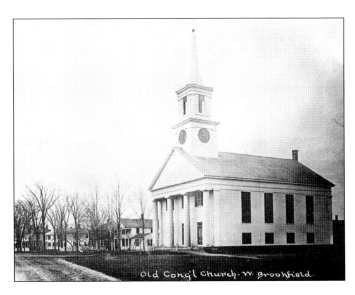

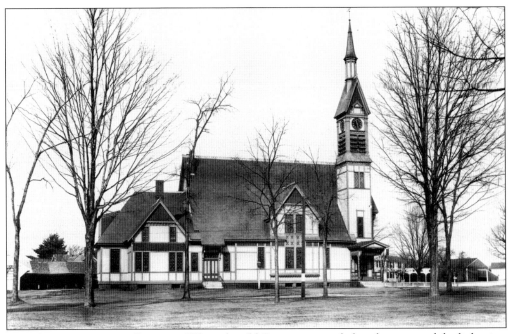

NEW CONGREGATIONAL CHURCH. When the old Congregational church was struck by lightning in 1881 and burned to the ground, nothing could be salvaged. Families owned their pews in the church and were saddened by the loss of this building. The new church was dedicated in 1882. It was built in Queen Anne style; many thought it ugly. George Rice donated the clock; George and Homer Merriam donated the 2,300-pound bell.

CONGREGATIONAL CHURCH, HURRICANE OF 1938. The tip of the steeple crashed through the church roof, stained-glass windows were blown out, and the porch landed across the street. Previously, the church had been rife with plaster and oil lamps falling from the ceiling. The new church built on this site opened in 1941 with the bell from the 1882 building now dedicated to Philander Holmes and a refurbished clock in the tower.

SACRED HEART OF JESUS CATHOLIC CHURCH. At the 1890 dedication of this church building and the Sacred Heart Parish, Father Burke of Worcester delivered the sermon, with Bishop O'Reilley of Springfield in attendance, the same day Sacred Heart Cemetery was consecrated. Trusses had to be built to support the building; they were completed in 1946. In June 1950, it became a separate parish with its first resident pastor. The church is located on West Main Street.

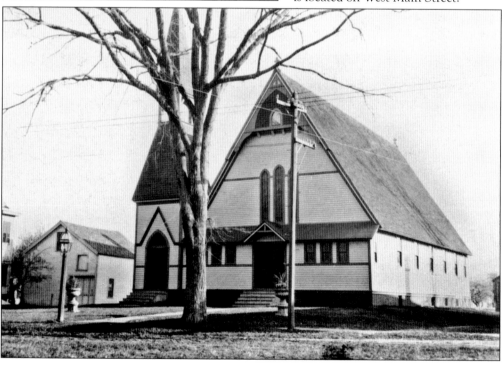

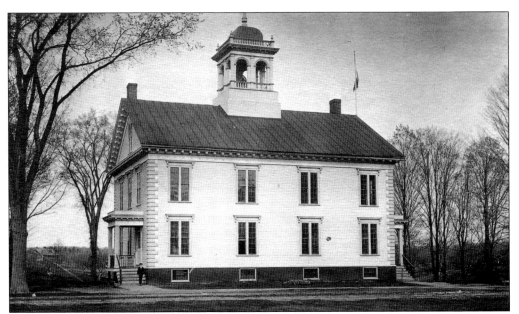

SCHOOL STREET SCHOOL. Opened in 1861 on the common, this District 1 School originally housed grades one through six from the central district and grades seven through nine from all six districts. Entrances were designated for girls on the left and boys on the right. In 1922, the state inspector required all outhouses be replaced with flush toilets, and electric lights were installed in 1922–1923. Miss Kelly's eighth-grade class is pictured below in 1932. From left to right are (first row) Clifton Pratt, Ralph Allen Jr., Thomas Crowley, and Robert Chapin; (second row) Russell Fenner, Grover Mitchell, Russell Parker, Joseph Beeman, Hudson Bennett, and Raymond Chapin: (third row) Robert Buzzell, Mildred Payne, Alice Payne, Adela Swedarsky, Hazel Nichols, Bertha Bristol, Louise Merrill, and Albert Braman; (fourth row) Bertha Connelly, Sylvia Melvin, Tablia Palzmski, Nola Squires, Mary Meome, and Bertha Cortis. (Above, photograph by Charles H. Clark.)

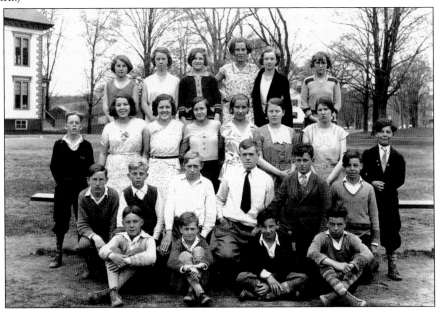

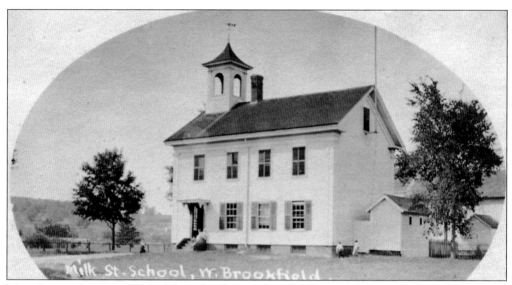

MILK STREET SCHOOL, 1920s. This school opened in 1872 and served as a primary and grammar school. In 1922, parents and teachers sought to have electricity and the toilet facilities and ventilation up to state requirements (note the outhouses to the right of the school). Pictured here are members of Rosamond Benson's first-and-second-grade class in 1926, some of whom are found on page 97 as eighth-grade students. From left to right are (first row) Bertha Connelly, Annie McRevey, Blanche Pratt, Madeline Balcom, Sylvia Melvin, and Myrtle Adams; (second row) Clifton Pratt, Edward Dame, Basil Rice, Robert Mason, Bertha Bristol, Ralph Allen Jr., Francis Walsh, Hudson Bennett, and Raymond Wheeler; (third row) Gilbert Merrill, Donald Melvin, Herbert Shaw, Clifford Ledger, Grover Mitchell, unidentified, Raymond Chapin, and Oliver Davis. (Above, photograph by Eddy Make.)

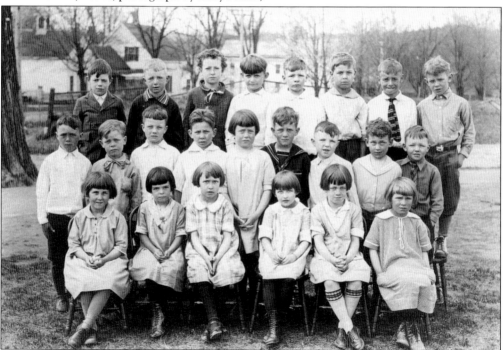

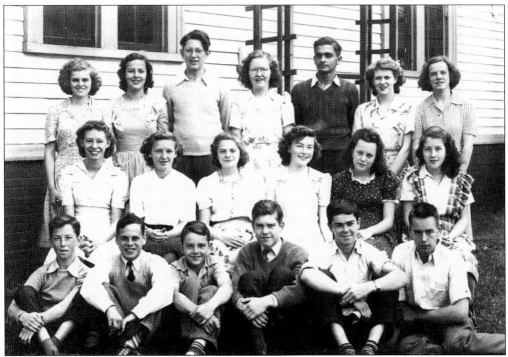

WEST BROOKFIELD ELEMENTARY SCHOOL. Members of the 1945 junior high class are, from left to right, (first row) David Walsh, David Foley, Ralph Richardson, Clyde Gail, Myland McRevey, and John Whitman; (second row) Beryl Stone, Dorothy Cook, Dorothy Smith, Arlene Poti, Doris Smith, and Ruth Hathaway; (third row) Kathleen Houlihan, Shirley Smith, George Gilman, Ruth White, John Finney, Jane Sampson, and Ruth Donnelly.

STUDENTS IN THE TREES. By the 1890s, the District 1 School Street School encompassed all students in first through ninth grades and their teachers. When the school first opened after being built on the east side of the common, where the bandstand is now located, there was no street. When the street was installed in 1913, it had to be closed during recess and lunchtime for the safety of the students.

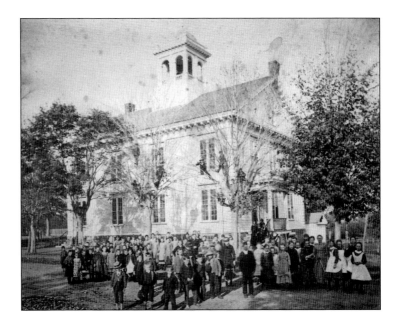

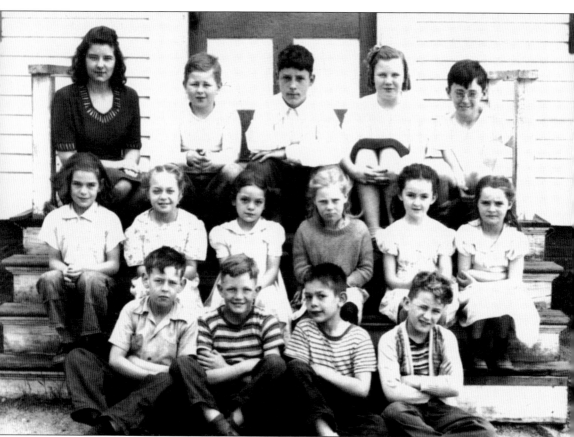

DISTRICT 2 SCHOOL. The Wickaboag Valley School, like the other smaller district schools, housed the primary students, grades one through six. During the school year of 1878–1879, citizen David Stebbins donated bells to all the schools for District 1 through District 6; he received high praise from the school committees of the West Parish schools. In 1946, this was the last one-room schoolhouse still in use in town. In 1952, it sold at auction for $24,000. The bell from this school was given to the Sacred Heart Parish. The class of 1947–1948 is pictured here. The photograph includes, from left to right, (first row) David Varnum, Richard Buzzell, Charles Whitman, and Nelson Comstock; (second row) Claudia Whitman, Louisa Pierce, Barbara Whitman, Alice Lindsay, Fern McRevey, and Arline Lindsay; (third row) teacher Elizabeth Kennedy, Robert Langley, Raymond Lindsay, Barbara Langley, and Paul McRevey.

Eight

MAYHEM AND DISASTERS

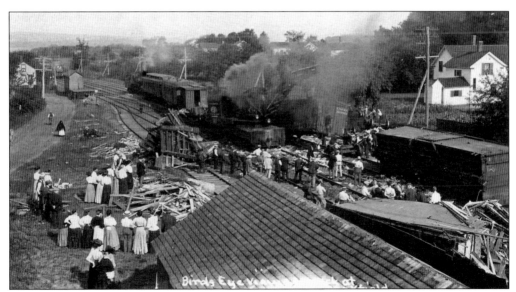

FREIGHT TRAIN WRECK, AUGUST 1907. A wrecker cleans the remnants of a train that ran into the back of another freight train stopped to load water. Wreckage of the trains covered all five tracks at the depot. Two men, believed to be vagabonds, were killed in this crash. The engineer of the train that crashed into the stopped train was charged with manslaughter.

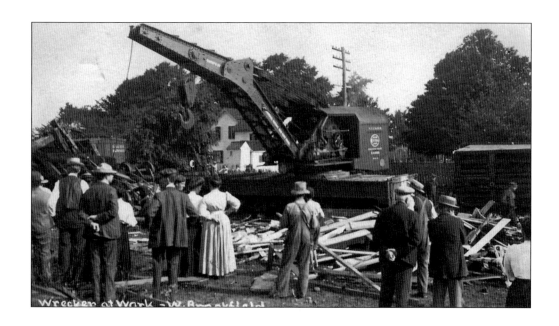

CLEARING WRECKAGE, AUGUST 1907. The crane continues to clear the tracks at the West Brookfield depot. Ladies, gentlemen, farmers, and even barefoot children have arrived to observe the process. It was learned, over time, there was limited visibility at this stretch, and engineers running late from the west could make up time by increasing speed on the "Brookfield flats." This was the second train wreck in 1907—the first occurred in January, when chickens and turkeys got loose when boxcars collided. Although some fowl died, there were no human losses. (Above, photograph by Eddy Make; below, photograph by Charles H. Clark.)

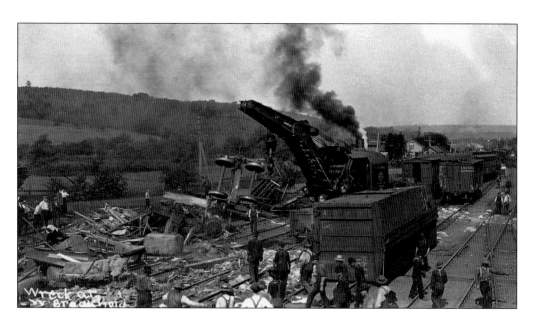

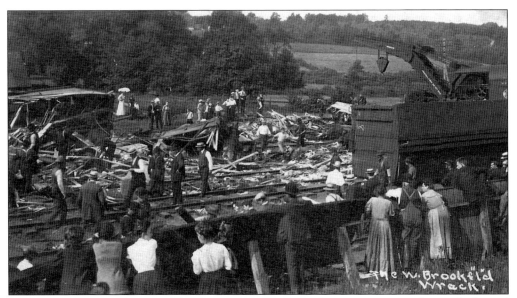

DEBRIS SCATTERED. Cleanup of the August 1907 train wreckage continues with smartly dressed ladies and gentlemen in the middle of the wreckage, quite frightening to observe now in the age of the Occupational Safety and Health Administration (OSHA) with its standards of protection and well-being for all persons on a worksite. (Photograph by Eddy Make.)

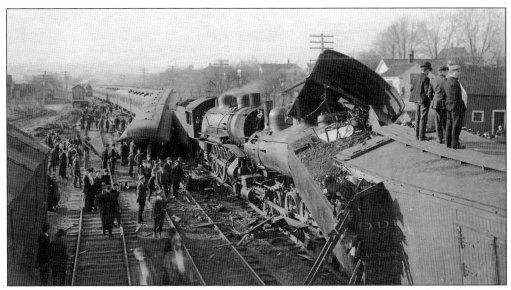

TRAIN WRECK, NOVEMBER 9, 1907. Within months, West Brookfield suffered another major collision at the depot, in about the same area as the August accident. An eastbound passenger train steamed directly into a westbound freight train that was stopped on the tracks. The head brakeman of the passenger train was killed instantly; a second brakeman was injured. The crew on the freight train jumped clear before the crash and escaped with only bruises. (Photograph by Charles H. Clark.)

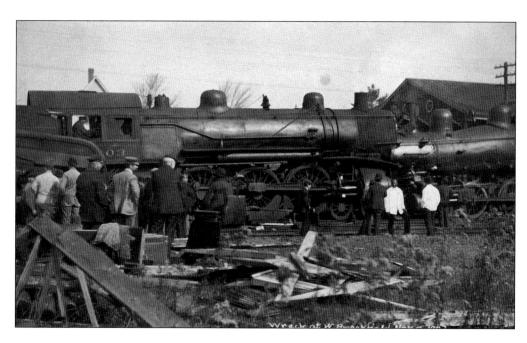

HEAD-ON CRASH, NOVEMBER 1907. Hundreds of people from the surrounding towns came on Sunday to view the Saturday wreckage and "souvenirs by the bushel were carried away." Several photographers came and took many images of the train wrecks. One photographer from East Brookfield, J.J. Mack, took 7 views and sold nearly 3,000 postcards printed from them within days of presenting them to the public for purchase. Charles H. Clark, proprietor of Clark's Drug Store in the Conway and Wheeler Block of West Brookfield, also took many images, but we have no report on how many he took or how many he sold. We do know his postcards were available soon after the wreck, as one is postmarked November 11, 1907. (Photographs by Charles H. Clark.)

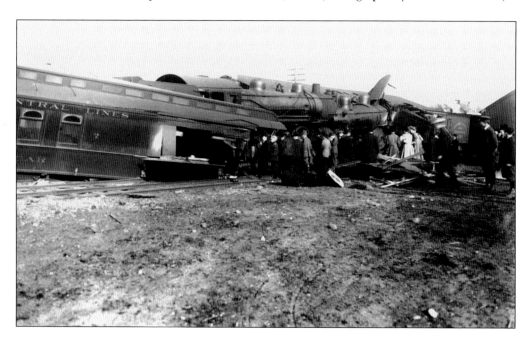

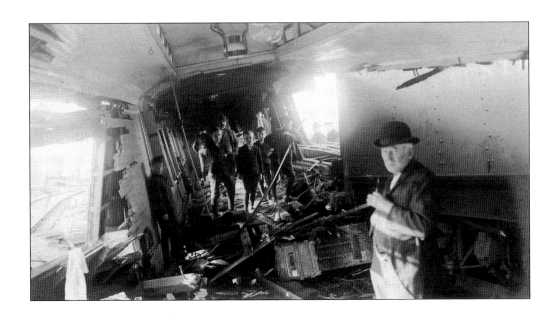

BOSTON AND ALBANY RAILROAD. Adults and children explore the wreckage of the November 1907 train crash. They pose in the dining car, noticeably cleared of seats and tables for the passengers due to souvenir collectors. This conduct at an accident scene is forbidden and unthinkable today. The Boston and Albany Railroad clearly improved safety measures for rail travel, with bells, gates, and lights at road crossings, and they also included better communication for employees regarding which tracks to use when approaching depots. The next incident reported was in 1955 with no injuries; a 53-boxcar freight train carrying automobile frames that shifted hit the overpass on Long Hill Road. The train bridge collapsed and left many homeowners, along with four businesses, stranded with no access to town.

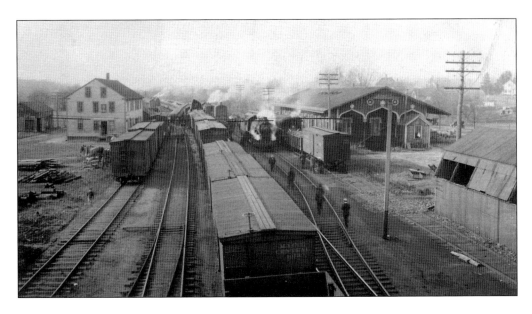

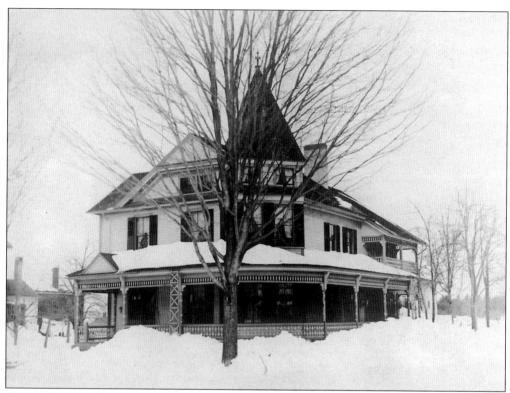

GOULD HOME ON COTTAGE STREET. On the quiet winter evening of February 15, 1902, the beautiful home of T. Elmer Gould suffered a terrible explosion that rocked the town. The cause was an acetylene gas generator used to provide lighting throughout the home. Located two houses behind the town hall, it was a well-built 2.5-story house said to have all the modern conveniences; the acetylene gas plant had been installed in the basement the previous fall. Five people were home at the time of the explosion: T. Elmer Gould, Fanny Gould, Mary Tomblen (a visitor), Carrie Fenton of New Britain, Connecticut (Fanny Gould's sister), and Margaret Leahy (domestic help). Mr. Gould was on his way downstairs with a lit candle to shut the machine off because something was wrong with the lights.

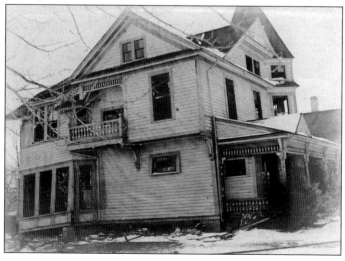

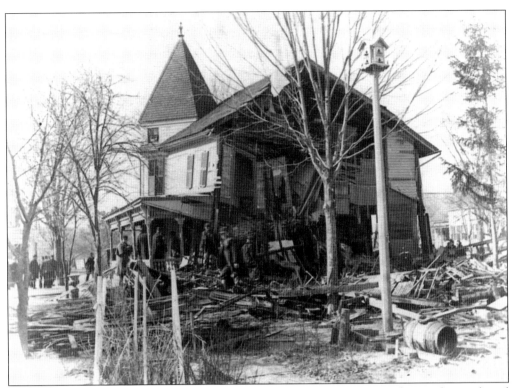

TRAGIC EXPLOSION. The explosion blew T. Elmer Gould and Margaret Leahy out the north end of the house, and both were found unconscious in the yard and badly injured. They were taken to St. Vincent's Hospital; Leahy died the next day, and Gould had his right foot amputated. He, too, later passed away due to his injuries. As the firemen extinguished the flames, the search of the ruins revealed the burned bodies of Fanny Gould, her dear friend Mary Tomblen, and her sister, Carrie Fenton. The firemen guarded the house so valuables would not be taken. The neighboring homes suffered damage from the blast, including the town hall and public library, with broken windows and cracked and falling plaster. All homes with a similar gas machine were ordered turned off and removed. This home was rebuilt for their surviving daughter.

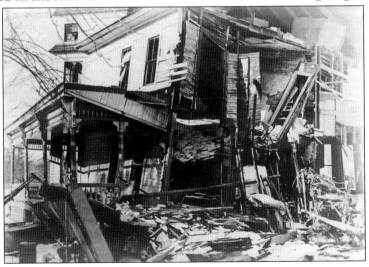

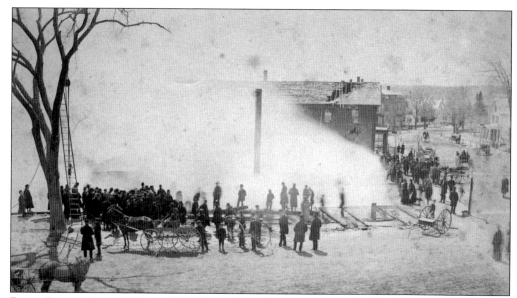

BLAIR BLOCK FIRE, 1887. In 1879, Ezra Blair built a block of stores across the street from the town hall, which he and several other businesses moved into. The fire was discovered at 4:00 a.m. by the cook at the West Brookfield House, now Ye Olde Tavern. Although firemen battled the fire, it raged on; an explosion lifted the building two feet off its foundation. The block was a total loss.

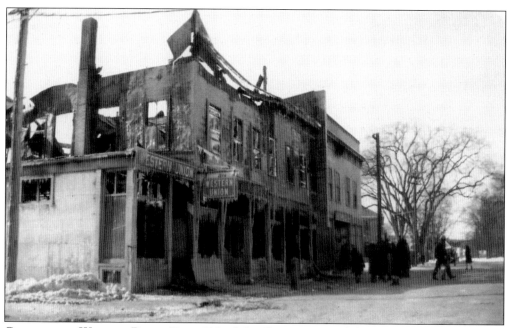

CONWAY AND WHEELER BLOCK FIRE, 1931. John Conway opened this block, the third building on the site of the original Blair Block on East Main Street, in 1893. He built it with steel on the roof and sheet steel to look like bricks on the walls, and he built a concrete firewall to separate the building into two sections. This 1931 fire destroyed only the east side of the building.

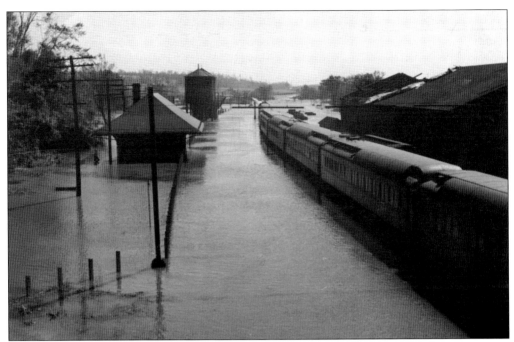

DEPOT, HURRICANE OF 1938. On a quiet Wednesday in September an unexpected hurricane tore up the coast of New England, barreled into central Connecticut, and continued on to central Massachusetts. By 3:30 p.m., the town's power lines were down, and with them, any means of communication. With no power, the pumps for the town's water supply were cut off; service was restored with the pumps from the town's fire trucks. Rail traffic was stopped when the railroad bridge over Coy Brook and a thousand feet of track were washed out. The east end of the Boston & Albany freight house roof was blown off. The water all around was at record-breaking heights. Below, the back side of the freight house roof can be seen at center.

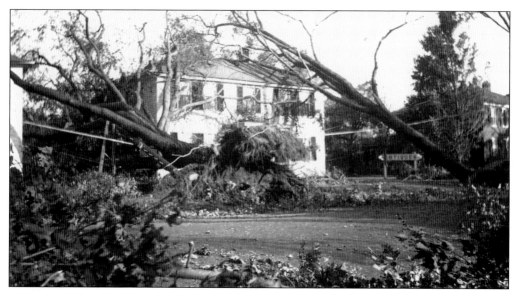

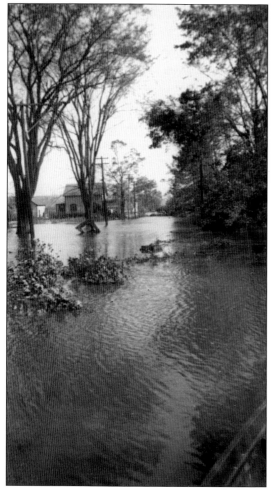

THOUSANDS OF TREES DOWN. From a profusely wet summer, the ground, rivers, lakes, and ponds were already overflowing at the banks. The hurricane ravaged and tumbled trees; due to the sodden ground, many trees just lay uprooted. The beautiful grove of pines on the eastern shore of Lake Wickaboag were tossed like matchsticks. This home and antique shop are located on North Main Street.

WATER EVERYWHERE. The Hurricane of 1938 was referred to as the "Great Hurricane" and the "Long Island Express." Even three and four days after the storm, the water was slow to recede, and in the remaining trees still standing along the Quaboag River many snakes could be found amongst the branches. The Naultaug Brook caused a washout 8 feet deep and 25 feet wide on the road to Warren.

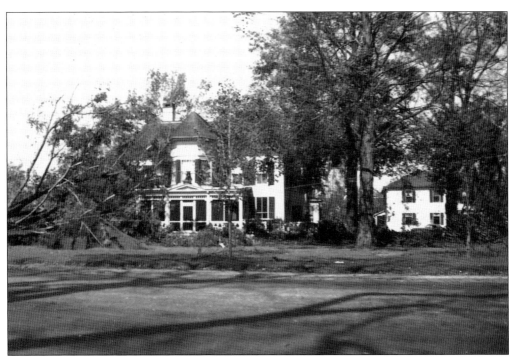

HURRICANE DAMAGE TO BUILDINGS. About a dozen barns were blown down, chimneys fell, and parts of roofs flew off. The Congregational church suffered the most damage, with the steeple embedded on the roof, the porch blown across the street, and stained-glass windows blown out. Sacred Heart Church lost its stained-glass windows over the altar, and the walls were so weakened the building needed trusses built to protect it. The public library was the least damaged public building, losing only a couple of windows. Although there were over 600 deaths along the coastline, there were no fatalities in West Brookfield. Above, trees are uprooted at the Olmstead house next to the public library; below, a disabled Chevrolet attempts to descend Foster Hill Road.

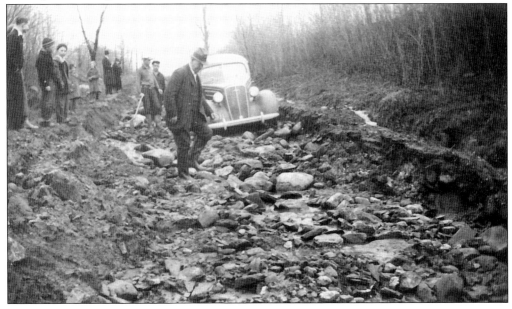

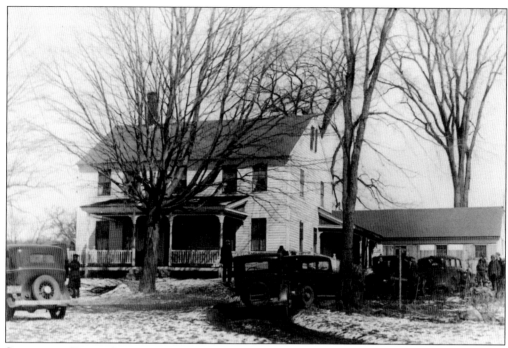

SWEDARSKY FARM, CUTLER ROAD, 1934. Officials arrive at the scene of a murder-suicide. A farmworker, 32-year-old Ralph Moulton, was infatuated with Swedarsky's 18-year-old daughter, Algonia. Moulton was asked to leave when his attention became troublesome; he instead attacked Swedarsky with a penknife. After serving six months in prison, Moulton tried to renew his friendship but was repeatedly told to stop bothering the family. In March, Moulton waited for Swedarsky in the barn and attacked him. Swedarsky managed to run away for help. Moulton then went to the bedroom of the sleeping daughters, stabbed and killed younger sister Adela, and then stabbed Algonia and pushed her down the stairs; she escaped. When police arrived, it took them three hours to find Moulton; he went headfirst down the well. Below, from left to right, are George Boothby, Clarence Hocum, Francis McRevey, and trooper Victor Nelson.

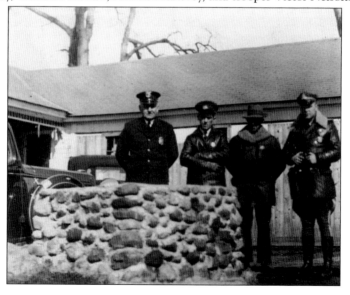

Nine

CELEBRATIONS

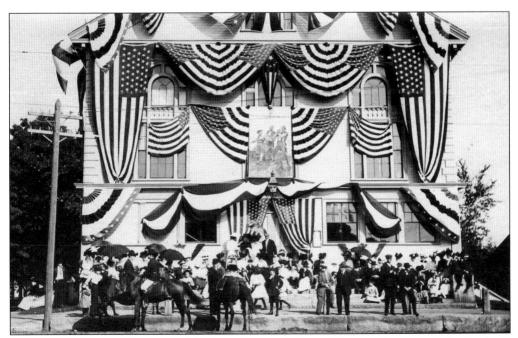

CELEBRATION, 1910. More than 8,000 people attended the 250th anniversary of the Quaboag Plantation, which took place on Wednesday, September 21, 1910. The celebration of the first settlement on Foster Hill began with all the Quaboag towns' churches ringing bells at dawn; they rang again at dusk. Here, a crowd gathers outside the West Brookfield town hall, which is decked out in patriotic bunting with trolley wires overhead.

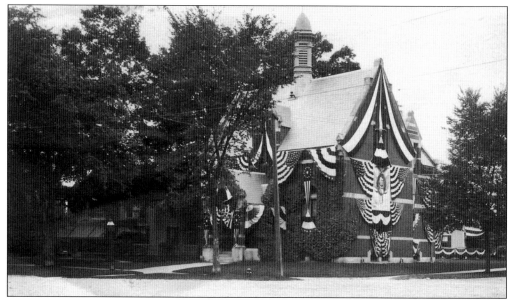

MERRIAM PUBLIC LIBRARY, 1910. This 1880 building was festooned for the Quaboag 250th celebration (above). Recent improvements had been made to the library's lighting, including the removal of stained-glass windows, and in 1916 the gas lighting was upgraded to electric lighting. Library trustees B.S. Beeman and Harold Chesson rode on the "Webster's New International Dictionary on Parade" float in 1910 (below). Dictionaries were too expensive for the average personal library when published in the 1830s; Webster did not sell many at the $15 price. They became more affordable when printers George and Charles Merriam purchased the rights to Webster's dictionary from his estate in 1843 for their Springfield printing house. The Merriam brothers, along with their three other brothers, were trained by their father, Daniel, and uncle Ebenezer—who established their West Brookfield printing house in 1794 and ran it until 1848.

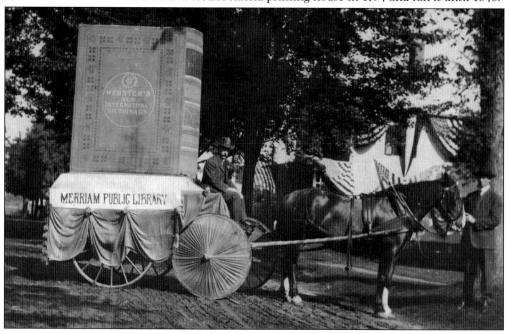

CELEBRATION ON THE COMMON, 1910. The 250th anniversary commemorative book notes, "Mammoth tents pitched on the northern portion of the Common added their gay decorations to the swelling symphony of color. The largest of these, two hundred and fifty feet long, was to be used for the literary and musical features, while two more, each one hundred feet, were to house the multitudes at dinner." (Photograph by Charles H. Clark.)

CONWAY AND WHEELER BLOCK. In 1909, fourteen committees were appointed to prepare for the September 21, 1910, celebration. Each committee had a member from West Brookfield, Brookfield, North Brookfield, and New Braintree. The Honorable Theodore C. Bates of North Brookfield was the chairman of the executive committee. Bunting, as well as banners bearing portraits of Presidents Washington, Lincoln, and Taft, were hung from many buildings, including this store block.

ORGANIZERS' APPREHENSION CONCERNING WEATHER. When organizing, scheduling, and keeping in order every event and detail for the celebration, the one thing no one could control or predict was the weather. The weather was brilliantly successful; in the early morning, a heavy shower calmed the dust on the country roads and cleared the air. The face of the rising sun presented a cool, crisp, autumn air over the Quaboag landscape.

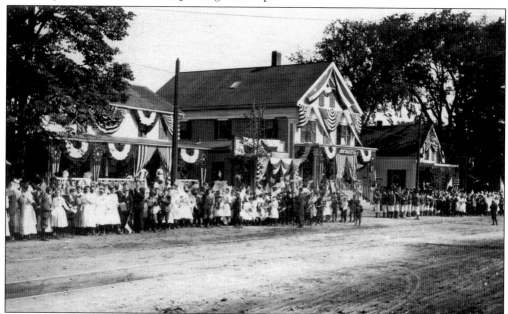

PARADE PREPARATIONS, 1910. The parade began to form soon after 8:00 a.m. Hundreds of school children in grades five through nine, from all the Quaboag towns, lined up to march. The Merriam Public Library float followed the children, and members of the Grand Army of the Republic followed in their blue-and-white uniforms. Groups of folks streamed to the common from every corner.

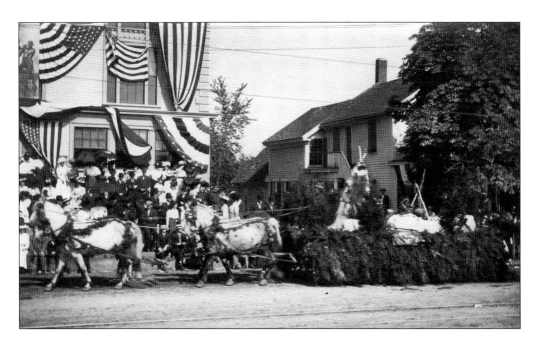

IMPROVED ORDER OF RED MEN. Above, the float of the Improved Order of Red Men followed the Woman's Christian Temperance Union and the Friendship Lodge of North Brookfield. The float representing the Lashawa Tribe of East Brookfield was arranged to represent an Indian camp with a wigwam, tripod, and kettle, surrounded by forest scenery. It was driven by Paul Cummings. Below, 40 members of the Quaboag Tribe parade on horseback, fully painted and in Native American dress, followed by another 20 members dressed in white duck trousers and black coats, carrying canes. They are organizing on Main Street in front of what is currently the Haymakers Grille (the one-story building between the two larger ones).

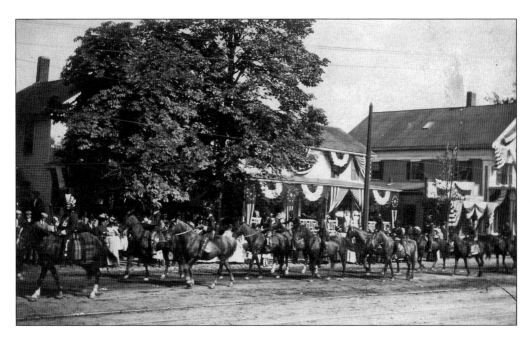

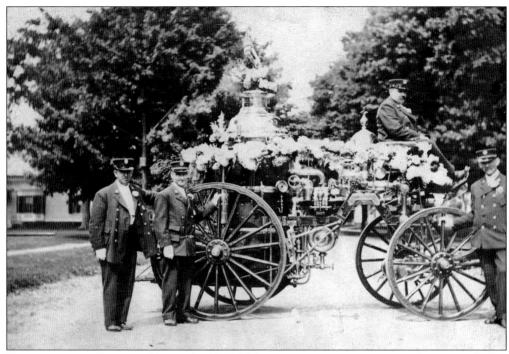

FIREFIGHTERS ON PARADE. Above, the 1888 Silsby steam engine rotary pump *American* of West Brookfield was driven by W.H. Bruce, while Henry Bartlett drove the 1874 Fullam hook and ladder truck. Below, the West Brookfield Fire Department marches in the 1910 parade with 22 men under the command of foreman John P. Cregan, and fire engineers George N. Sanford and George H. Boothby. All the area fire departments were represented with their equipment. The North Brookfield Holmes Steamer Company was present with 42 men in uniform, under Chief Engineer Harold A. Foster. The Brookfield Fire Engineers came next with Edward F. Delaney, Albert Bellows, and Robert Livermore, followed by the Steamer Company No. 2 of Brookfield, with 18 men and the steamer.

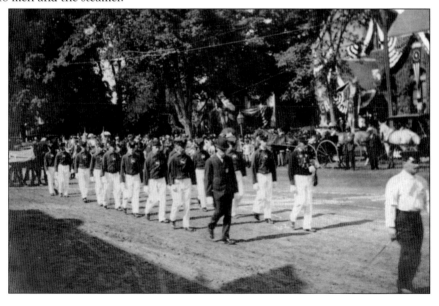

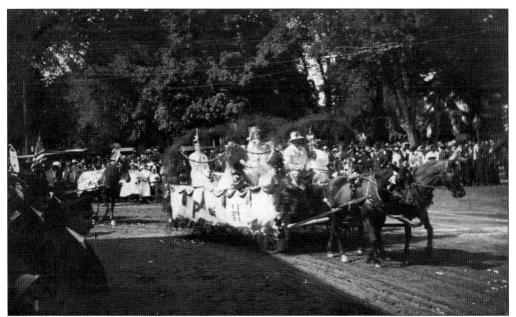

NEW BRAINTREE GRANGE. The National Grange Order of Patrons of Husbandry is the official name of the organization of the Granges. Founded in 1867, it focused on family and community, with its roots in agriculture. Faith, hope, charity, and fidelity are the basic lessons of the community Grange. New Braintree Grange is still active and meets the second Wednesday of the month at 7:30 p.m.

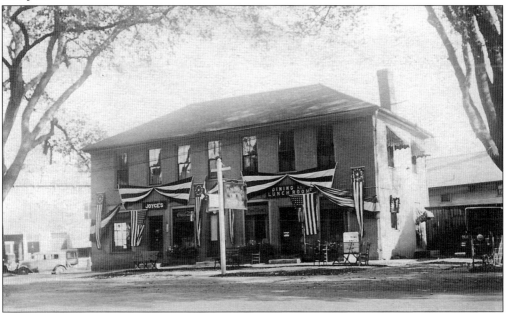

TERCENTENARY OF THE MASSACHUSETTS BAY COLONY. In October 1930, the commonwealth of Massachusetts celebrated its 300th anniversary. In West Brookfield, the day began at 7:30 a.m. when Raymond Richardson, dressed as Paul Revere, rode on horseback heralding the coming of the town crier who would announce the day's schedule of events. Charles Burgess Jr., as the town crier, made the announcements an hour later. This building is currently the Country Bank.

PARADE, 1930. Cars line up in front of Ye Olde Tavern. The parade began at 2:00 p.m., with the parade marshal and color guard from the American Legion at the head, followed by the bands and automobiles holding or representing prominent citizens such as Civil War veterans Edwin Wilbur, Jedediah Foster, and Arthur Warfield Jr. They were followed by cars holding the selectmen and the speakers of the day.

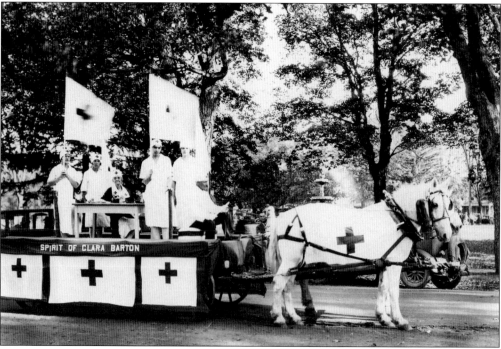

"SPIRIT OF CLARA BARTON." More than 15 floats represented town organizations, schools, and businesses. Born in 1821, Clara Barton was a teacher, patent clerk, and Civil War nurse. While visiting Europe, she worked with a relief organization known as the International Red Cross and lobbied for an American branch when she returned home. The American Red Cross was founded in 1881, and Barton served as its first president.

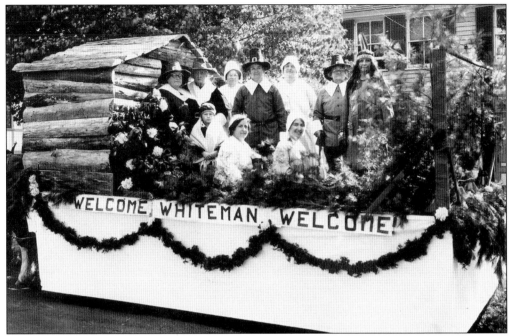

"Welcome, Whiteman, Welcome." For the 1930 statewide celebration, established holidays—such as the Thanksgiving holiday portrayed in this float—were given a 300th anniversary focus, including a combined Washington-Lincoln public meeting on Washington's birthday, tercentenary events in the programs for Evacuation Day, Patriots' Day, and Bunker Hill Day, and particular attention in the regular celebration features on Independence Day, with a pageant of Boston given twice on Boston Common.

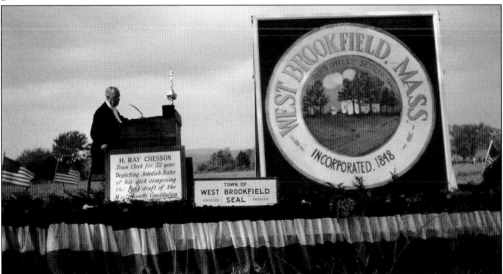

Quaboag Plantation Tercentenary. The 300th anniversary of the Quaboag Plantation was celebrated September 16–18, 1960. Five towns participated: the four Brookfield towns and Warren. H. Ray Chesson, town clerk for 32 years, presided on the float with the West Brookfield town seal, representing Jedediah Foster, who assisted in drafting the Massachusetts Constitution. The float was brought to Foster Hill as part of the historical pageant held there.

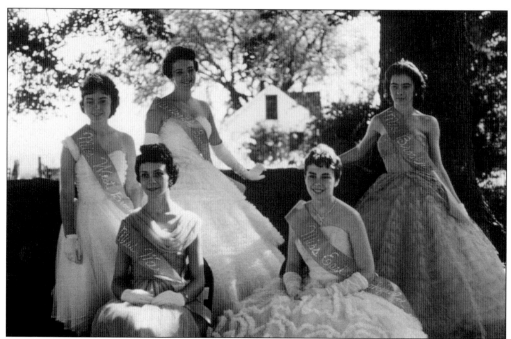

300TH ANNIVERSARY OF QUABOAG PLANTATION. A preliminary event to the 1960 celebrations was held September 9 at the North Brookfield High School auditorium. Miss Quaboag was selected from the towns participating. In the above image, seated at the Fort Gilbert 1688 marker on North Main Street are, from left to right, (first row) Ruth Mitchell (Miss Warren) and Barbara Cote (Miss East Brookfield); (second row) Lona Bell (Miss West Brookfield), Annette Valencourt (Miss North Brookfield), and Gail Nichols (Miss Brookfield). Valencourt was crowned Miss Quaboag. Homecoming events were held in each town on the Friday of the big weekend, and on Saturday, a grand parade for all the towns was held in West Brookfield, winding around all the back and side roads to appear on the main route. More than 3,000 people participated in this parade, and the audience was estimated at 30,000.

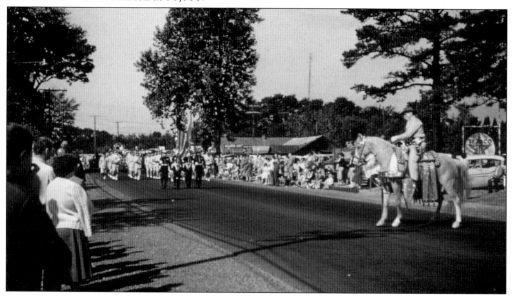

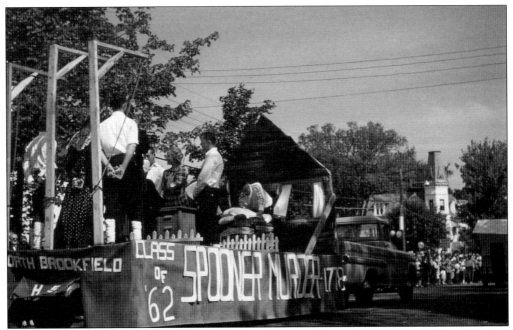

SPOONER FLOAT, 1960. The North Brookfield High School class of 1962 presents a tableau of the infamous Spooner case, showing the convicted murderers on the day of their execution in July 1778. Bathsheba Spooner, Continental army soldier Ezra Ross, and British soldiers Williams Brooks and James Buchanan were all hanged for the death of Bathsheba's husband, Joshua Spooner, a Brookfield community leader whose body was found in the family's well.

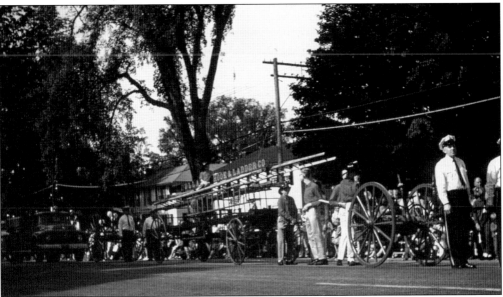

FIRE DEPARTMENT, 1960. The 1855 hand tub, 1874 Fullam hook and ladder truck, and modern equipment are presented together in the Quaboag 300th anniversary parade. The 14 auxiliary firefighters were included and considered part of the office of civil defense; total staffing was 148. After the parade, a firemen's muster took place, along with a road race, concert, and square dancing; at 10:30 that night, there were fireworks on Foster Hill.

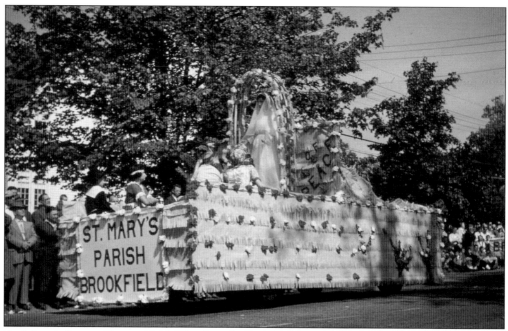

St. Mary's Parish Float, 1960. The float for Brookfields' St. Mary's Church in the 1960 parade gives emphasis to the statue of St. Mary. The church was built in 1754 with timbers from the 1717 Foster Hill meetinghouse in West Brookfield. At first, it served the Congregationalists and Unitarians; the building was moved to its current site on Lincoln Street in Brookfield in 1867, to serve the Catholics.

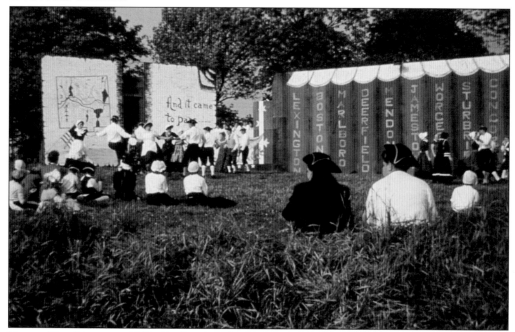

Foster Hill Pageant, 1960. On Sunday, the final day of the celebration, a historical pageant took place on Foster Hill. The three-part play, *The Book of Quaboag*, was performed in 11 scenes with 200 performers. The script was written by Mildred McClary Tymeson, a West Brookfield native.

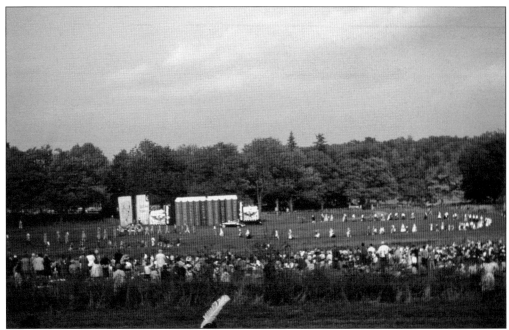

QUABOAG TERCENTENARY PRESENTATION. More than 2,000 people attended the show on Foster Hill, held on September 18, 1960, a beautiful fall day. The finale to the celebratory events was a Wickaboag Ski Club waterskiing show on the lake. A souvenir to commemorate the 300th anniversary included a bronze medal (or coin) depicting the attack on Quaboag Plantation during King Philip's War.

QUABOAG PLANTATION TOWN CRIER. The owner of Stanley's Central Market on Central Street was Stanley Stachowicz of West Brookfield. He was the town crier for the celebration of the 300th anniversary of the Quaboag Plantation. Dressed in period costume, he called out the schedule of events for each day of the three-day celebration after ringing the bell for attention.

BROOKFIELD AIRPORT. Single-engine airplanes competed at this September 11, 1949, air show on the West Brookfield/Brookfield line. According to the *Worcester Telegram*, airfield owner Gus Willet gave a beautiful exhibit of stunt flying in a Fairchild PT-26. Talent competitions included landing flour bags on the circular target in the field (front center) and coasting the closest to the finish line after landing with the motor off. (Photograph by Gray Studios.)

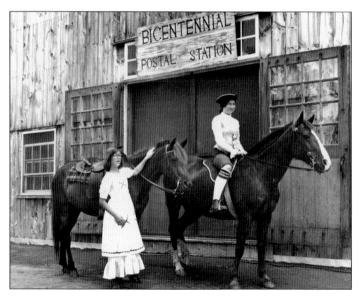

MAIL DELIVERY, 1976. Jennifer Richards (left) and Donna White prepare to reenact a mail delivery for the Fourth of July celebration held in West Brookfield in 1976, the year of the nation's 200th anniversary. This Bicentennial Postal Station was set up at Salem Cross Inn as part of the demonstration. Commemorative envelopes were available with the 1976 date stamped on them. (Photograph by J. Irving England.)

GEORGE RICE MEMORIAL FOUNTAIN. Above, J. Irving England (right) receives the 1986 Massachusetts Historical Commission Award from Sen. Edward Kennedy for funding the successful replacement of the top figure of the 1885 Rice Fountain on the common. The top figure was totally destroyed by the Hurricane of 1938. Adio DiBiccari, a nationally renowned sculptor from Boston, was hired to recreate the lady from a 1930s photograph. New plumbing and pumps were installed to bring the fountain to full function. A formal unveiling ceremony was held on November 23, 1985, a century after the original installation; and the Rice Fountain once again welcomed visitors to the West Brookfield common. Pictured at right are, from left to right, Mert Baker, Edward Takorian, Louise Jankins, J. Irving England, sculptor Adio DiBiccari, and assistant David Calvo.

DISCOVER THOUSANDS OF LOCAL HISTORY BOOKS
FEATURING MILLIONS OF VINTAGE IMAGES

Arcadia Publishing, the leading local history publisher in the United States, is committed to making history accessible and meaningful through publishing books that celebrate and preserve the heritage of America's people and places.

Find more books like this at
www.arcadiapublishing.com

Search for your hometown history, your old stomping grounds, and even your favorite sports team.